van gogh

Text by
FRANK ELGAR

SPURBOOKS LTD
LONDON

Published by
SPURBOOKS Ltd
LONDON, 1975
ISBN 0.902875.75.2
Printed in Italy

Vincent Van Gogh was born in 1853 at Groot-Zundert, in North Brabant, Holland. If, in December 1885, Van Gogh had not experienced a near-blinding revelation as a result of which he produced the masterpieces of the five last years of his life, he would no doubt be hailed today as a great painter of labour and poverty, of workmen and peasants overwhelmed by weariness, the first of the Dutch Expressionists. He became a painter in order to solve an inner conflict by which he was torn, to take his revenge in the domain of art for the failures he had experienced in his life. He was of a Protestant family, a family of clergymen. But two of his uncles were art dealers, a fact that allowed him to start out in The Hague as a salesman in a gallery recently sold by one of them to the firm of Goupil of Paris. Vincent was sixteen then. Four years later, he was sent by his firm to London, to work in the English branch. In London he fell in love with his landlady's daughter. He asked her hand. He was turned down.

Unstable by temperament, acutely nervous, too sincere, he was deeply dejected by this first failure. He left London and went to work at Goupil's head office in Paris, in 1875. He was

immediately borne away upon the current of ideas of which Paris was then the centre. He read all the books within his reach, visited museums, underwent the influence of humanitarian writers and of painters concerned with the sufferings of the humble. The Bible became the chief stimulus of this self-taught son of a clergyman.

He was dismissed by Goupil in 1876, and went back to England. He worked at a small school at Ramsgate, and then at another, where he did some preaching. He applied for a job as an evangelist among the miners. "I feel drawn to religion. I want to comfort the humble." His application was rejected. At Christmas of the same year he returned to Etten, to his parents, but soon there was conflict. From January 21st to April 30th, 1877, he was a clerk in a bookshop in Dordrecht. But he was unable to adjust himself to a practical and regular existence. Therefore, increasingly tormented by his religious calling, he went to Amsterdam to prepare for the entrance examination to the Theological College. After fourteen months of desperately hard work, he had to give up and return to his family. His exasperated father ended by entering him at the Evangelical school at Brussels. In December 1878, Vincent left for the Borinage in Belgium without waiting to be given an appointment. He undertook to bring the miners of this forsaken region back to Christ. He adopted their own poverty, slept on a board in

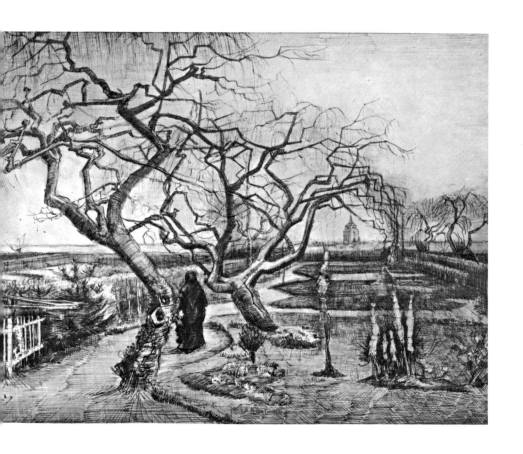

The Garden of the Presbytery at Nuenen. Winter, March 1884
Vincent Van Gogh Rijksmuseum, Amsterdam

a wooden hut, shared their sufferings, attended the sick, showed the exalted zeal of an apostle, but without success. He was then an ill-clothed, gawky, red-haired, fellow, with abrupt gestures and too bright eyes. His spirit of sacrifice seemed astonishing, his excessive asceticism alarming. Men pursued him with sarcasm, children feared him, and as for women-who could love this terrible man? His superiors got rid of him in July 1879. Then began one of the darkest periods of his life, months of poverty, moral distress, anguish, roving on the roads. To his brother Theo, who was about to enter Goupil's in Paris, he wrote a poignant letter, in which he announced his decision to devote himself to painting.

In October 1880, he was in Brussels, where he studied drawing and made copies from Millet. From April to December 1881, he stayed at Etten with his parents. He experienced another sentimental disappointment there. Turned down by his cousin, Kee, he went away and settled in The Hague. The painter Mauve, another cousin of his, took him in cordially and gave him useful advice. In January 1882, he met in the street a prostitute named Christine, who was ugly, drunk and pregnant. He took her with him. To this woman he gave all the love of which he was capable. The episode lasted twenty months, until he realized definitely that he was no better at individual love than at the love of humanity and the love of God. From

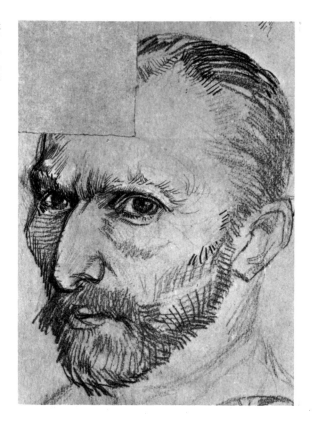

then on his humiliated pride took refuge in art.
With his artistic apostolate his misfortunes grew.
He quarrelled with his father, who disapproved
of his artistic career. He fell out with Mauve
and Israels, the teachers of The Hague School,
whose teaching had finally become unbearable

to him. Then, in December 1883, he returned to his father's house, this time at Nuenen, and courageously gave himself up to painting. He did studies of the heath, cottages, weavers, peasants, executed in the rough, black dismal manner of *The Loom* (1884) and *The Potato-Eaters* (V. W. Van Gogh Collection, Laren), his first large picture. His native tendency, the influence of his environment, the contagion of example—all incited him to persevere in this gloomy realism. How, then, can the radiant masterpieces that were to follow be explained?

In November 1885, he was in Antwerp. His father had just died. His brother Theo, with whom he had been in correspondence for five years, had sent him some money. He had discovered Rubens and the joy of life, and also Japanese fabrics, whose colours delighted him. He bought some, decorated his room with them, spent hours contemplating and studying them. He glimpsed an outlet for his still obscure desires, a new world of light, consolation, balance. He decided all of a sudden in February 1887 to leave for Paris. Theo received and sheltered him affectionately. He was dazzled by Impressionist pictures. He met Pissarro, Degas, Gauguin, Signac. In June 1886, he enrolled at the École Nationale des Beaux-Arts in the Cormon studio, where he made friends with Toulouse-Lautrec and Émile Bernard, who was eighteen then and with whom he kept up a regular correspondence. He worked desper-

ately. He painted streets of Paris, portraits, flowers. He exhibited a few canvases at Père Tanguy's among others by Monet, Guillaumin and Signac. His brother, who was then the manager of the Goupil Gallery, encouraged and backed him. Obsessed by Japanese prints, he copied *The Bridge under Rain* and *The Tree* of Hiroshige. His palette lightened; he even borrowed the Impressionist pointillist technique, as in the *Portrait of Père Tanguy* (1887, Musée Rodin) or in *View from the Artist's Room, rue Lepic* (1887). In the pictures of Pissarro, Monet, Guillaumin, he rediscovered the light handling and the fresh tones of the Japanese. But French Impressionism had caused a decisive shock to his thinking mind. He felt such a need to emulate the Impressionists that he did some two hundred pictures during the twenty months of his stay in Paris. This prolific and sometimes uncontrolled production includes outdoor scenes, such as *Fête at Montmartre* (1886), *Restaurant la Sirène* (1887), still-lifes such as *The Yellow Books (Parisian Novels)* and a series of twenty-three self-portraits, including the one at his easel (1888), which in a way marks the end of this period.

The winter of 1887 was an unhappy one for him. The grey sky, the gloomy streets, the sadness of the capital became unbearable to him. The Parisian painters could not give him more than he had taken from them. The rejuvenation he had received from their contact

was already exhausted. He needed light, heat, to warm his frozen soul and awaken his eagerness for work. Upon the advice of Toulouse-Lautrec, he went to Arles, on February 20th, 1888. In Provence everything delighted him, the orchards in bloom, the beautiful women of Arles, the Zouaves of the garrison, the drinkers of absinthe. He exclaimed with rapture, "This is the Orient!" He was thirty-five and felt happy. With ease and enthusiasm he drew with a reed, painted well-balanced canvases, firmly arranged, almost serene. At last he had found clear-cut contours, light without shadow, pure colour, dazzling, crackling vermilion red, Prussian blue, emerald green, sacred yellow, the emblem of the sun. He shed the finery of Impressionism, gave up the divided stroke, fragmented design, subtle modulations. Vigorous, precise, incisive, his line captured the inner structure of objets. He painted nearly two hundred pictures in fifteen months, executing three, four and sometimes up to five versions of some of them: *The Drawbridge at Arles, The Plain of la Crau, Sunflowers, Café at Night, L'Arlésienne (Mme Ginoux), The Postman Roulin,* his wife and their son, *Armand Roulin.* From a short stay at Saintes-Maries-de-la-Mer he brought back drawings and canvases, notably his *Barges on the Beach* (Laren) and a *Seascape* (Moscow). He left an admirable representation of his *Bedroom in Arles* (October 1888), of which he later made, at Saint-Rémy, one replica from memory.

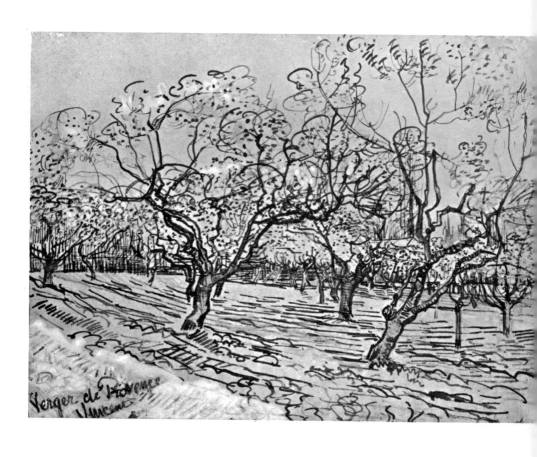

Orchard in Provence. April 1888. Vincent Van Gogh Rijksmuseum, Amsterdam

However, his material existence was most precarious. He did not have enough to eat. He sold nothing. He suffered from hallucinations and crises, from which he emerged dazed. The idea of death haunted him. As if he had a presentiment of his approaching end, he hurried, worked furiously, in a state of exaltation that saved him from despair. His mind was on fire. His pictures dripped with golden light. He was "in the centre of the universal fusion" that transmuted his colours and consumed his brain. Crises grew more numerous. He played with a project for an artists' colony that he would have called "The Studio of the South," where groups of men would work at projects in common. Late in October 1888, Gauguin responded to his appeal. Vincent was quite cheered up. But in stormy discussions the relationship between these two opposed natures soon deteriorated. On Christmas night, during a futile quarrel, Van Gogh threw his glass in Gauguin's face. The next day, Gauguin, walking in the street, heard hurried steps behind him. He turned and saw Van Gogh with a razor in his hand. Under Gauguin's steady gaze Van Gogh stopped, then fled to his room, cut off an ear with a stroke of the razor, wrapped it in a handkerchief and went to offer it as a present to a girl in a brothel. After two weeks in a hospital he came back to paint the extraordinary *Man with an Ear Cut Off* (January 1889). Meanwhile his hallucinations returned. Neighbours raised

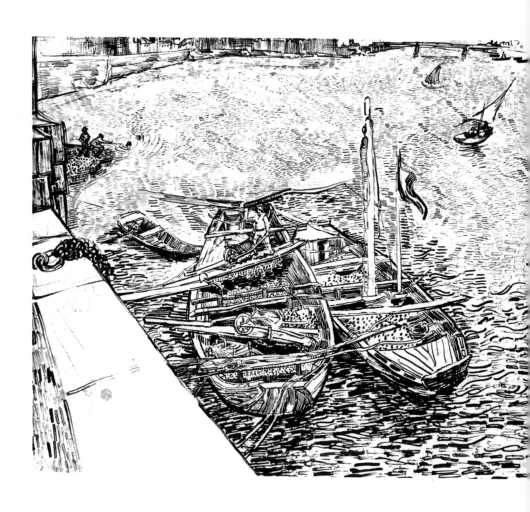

Moored Boats. August 1888. Private collection, New York

a petition for his internment. His unattractive appearance, his touchy character, his whims had alienated people. He had never analyzed his illness more clearly, endured men's hostility with so much resignation, or spoken of his art with more common sense and lucidity, but now he was considered mad. He was sent back to the hospital. In Paris, Theo, who was going to be married, became alarmed and sent the painter Signac to see him. Signac spent the day of March 24th with Vincent, who kept on painting, reading, writing, in spite of his crises. When he felt too ill, he asked to be interned at the asylum of Saint-Rémy-de-Provence, on May 3rd, 1889.

The Arles period was over, the most fruitful if not the most original of his career. During the year he remained at the asylum he produced another hundred and fifty pictures, and hundreds of drawings, working as one possessed, interrupted in his labour by three long crises, followed by painful prostrations. He painted *Yellow Wheat, Starry Night, Asylum Grounds in Autumn,* a few portraits including that of the *Chief Superintendent of the Asylum,* delirious landscapes, surging mountains, whirling suns, cypresses and olive trees twisted by heat. His colour no longer had the sonority of the preceding period; the yellows had become coppered; the blues darkened, the vermilions browned. In compensation, rhythm became more intense: whirling arabesques, dismantled forms, perspective fleeing toward the horizon

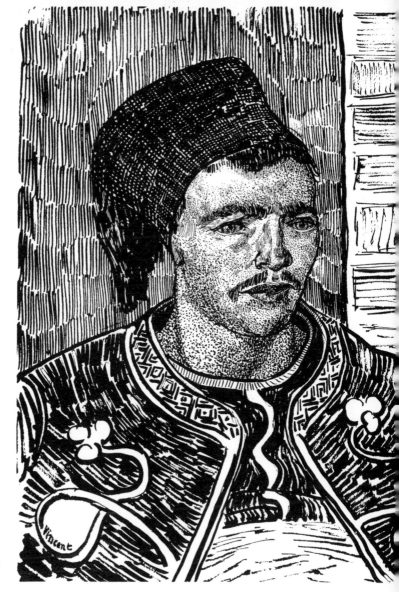

The Zouave.
June-July 1888.
Mr. and Mrs.
Justin K. Thannhauser
collection, New York

in a desperate riot of lines and colours. What he represented then on his canvases he seems to have seen through a vertigo of the imagination. The fire lit by his hand was communicated to his brain. A feeling of failure overwhelmed him. Could his works be inferior to those of the masters whom he admired? This thought frightened him. In February 1890, he learned of the birth of Theo's son, called Vincent after himself. The generous Theo, so indulgent a brother, at whose expense he, the failure as an artist, the painter incapable of selling a single canvas, had been living so long! Yet, in the *Mercure de France* the critic Aurier had just published the first article devoted to his work. This tribute brought him little comfort. He felt ill, exhausted. Vigilant as ever, Theo asked

Farmhouse in Provence
1888
Rijksmuseum, Amsterdam

Doctor Gachet to take Vincent under his care at Auvers-sur-Oise. It was thus that Van Gogh came to Paris, on May 16th, 1890, and settled soon at Auvers. Doctor Gachet attended him, showed him an affectionate friendship, served as a model for him. For Vincent had resumed painting. He did his last self-portrait, now in the Louvre, *The Church of Auvers*, also in the Louvre, *The Town Hall of Auvers,* the *Portrait of Mlle Ravoux,* that of *Doctor Gachet* (Louvre), and other works, for which he had at his disposal only a technique which had already begun to disintegrate. He feared a new attack of his illness. An unspeakable sadness invaded him. Go on working when the hand refuses to obey, when the enemy within will now always be the stronger? What was the use of trying? That last Sunday in July, Vincent slipped out of the Pension Ravoux, where he was staying. He made for the fields of ripe corn, where a few days before he had painted the famous *Wheat Field with Crows*. The village was deserted. He stopped in front of a farm. Nobody there. He entered the courtyard, hid behind a dunghill and shot himself in the chest with a pistol. He had the strength to return to the inn, go up to his room and get into bed like a wounded animal. He died two days later, in the presence of Theo, who had hastened to his bedside. He was thirty-seven years and four months old.

Unbalanced, painful, tragic, such was certainly his life. That he suffered from neurosis

and epilepsy is equally true. Like Rousseau, like Baudelaire, Van Gogh felt very vividly that his life was a failure and suffered deeply from it. He was perpetually anguished, and against his anguish he tried various means of defence: religion, humanitarianism, art. He gave himself to painting with all the more passion as he saw himself threatened by an implacable disease. Lifted out of himself by art, he was able to overcome his physical failings, or at least not to think of them too much. This unstable, high-strung, obsessed man, in unceasing conflict with society and himself, created a body of work outstanding in its concerted perfection of ends and means. However impetuously inspired and executed it may be, this art is certainly not that of a madman. Although he put all of himself into his painting, Vincent never abandoned his very obvious concern for balance, order and reason. His shortcomings are more than offset by an activity which drew from his very failures enough vigour to fight against his weakness and live in his work. He might have sunk into mental chaos; instead, he triumphed through discipline, work and meditation. In the midst of his greatest discouragements, he retained his love of simplicity and harmony, sought a reconciliation of form and colour, an abstract, coherent transposition of the world. He gave himself an infallible system of principles and rules to reach the artistic ideal that he had glimpsed in his moments of acute insight. Each of his works

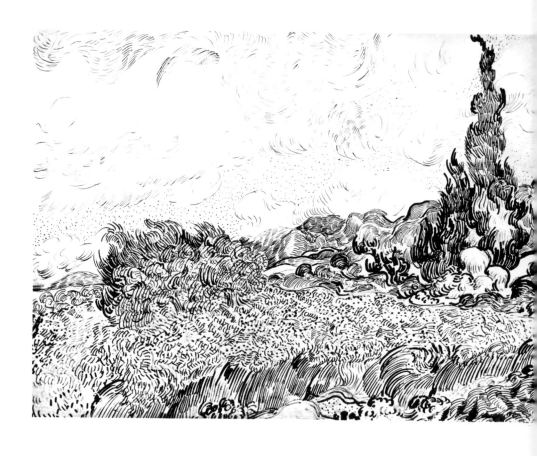

Cornfields With a Cypress. June 1889. Vincent Van Gogh Rijksmuseum, Amsterdam

was the fruit of a thought, a decision, a wish for serenity rather than for strangeness. What did he want? "Something peaceful and pleasant, realistic and yet painted with emotion; something brief, synthetic, simplified and concentrated, full of calm and of pure harmony, comforting like music." He tamed his exaltations and his impulses by the laws he had established for himself. Far, then, from being the painting of a madman, Van Gogh's is that of a thoroughly conscious artist and at the same time of a robust man, a dedicated creator. If anything, he saw too clearly. He sought always elements of a beauty of which he could find only an insufficient amount. "There is an art in the future, and it will be so beautiful, so young!..." What bitterness in this cry of hope! He hoped for, prepared, made possible a golden age of painting, knowing nevertheless that he would not see it. More assured of his victories than of profits, it was reserved to him, the discoverer and the pioneer, only to bequeath the means of success to those who came after him. In a way he triumphed over his illness, for his suicide prevented his madness. But he did not create the new art of which he had a presentiment and which he announced with moving certainty in his letters, because the moment for it had perhaps not yet come.

The sureness of his hand equalled that of his will. There is no groping, no working over, nor the slightest alteration in his landscapes or his

portraits, which were almost always undertaken directly on canvas, in the manner of the Japanese. "It is not only by yielding to one's impulses," he wrote, "that one achieves greatness, but also by patiently filing away the steel wall that separates what one feels from what one is capable of doing." So Van Gogh expressed the inner duel that eventually exhausted his strength.

But if the man died prematurely, the work remains, and contemporary painting was, in a great measure, born of it. Van Gogh appeared when the Naturalist fiction was casting its last glow with Impressionism, at a time when academic conventions were collapsing, when tradition was dying of old age. With Cézanne and Gauguin, he questionned the technique of painting and in doing so prepared for the art of the twentieth century. He used the picture not to imitate appearances or humour the tastes of a cultivated society, but to re-create the world according to his own intelligence and sensibility. While Cézanne was concerned with a new conception of space and Gauguin with composition, Van Gogh emancipated colour, carrying it to its maximum intensity and expressiveness. In his canvases colour reinforces drawing, accentuates form, creates rhythm, defines proportions and depth. It even acquires the value of a sign, addressing itself to the soul as well as to the eye: "colour not locally true," he said, "from the realistic point of view of *trompe-l'œil,* but

suggestive of some emotion." He used it raw, dry, aggressive, in abrupt harmonies, now strident, now muted, without shades, without semitones, with cruel frankness. "I have tried to express with red and green the terrible human passions," he also wrote. But he always refrained from sacrificing colour to form. And it is right that today his drawings should be admired as much as his pictures. He has left a great number of them, and all of them are surprising in their simplicity and acuteness of expression, their assurance and swiftness of line, the variety of the graphic means which the artist used to transcribe on paper the quivering elements of his vision. And this vision was thoroughly his own, of undeniable depth and originality. He has had no direct descendants, although his influence has been felt by all modern painting: Fauves like Vlaminck, Derain, Dufy, Friesz; the Expressionists, in particular Soutine. But Van Gogh was also a poet, a mystic, a thinker. No artist today raises more passionate an interest than he: his painting, his drawings, his correspondence. For Van Gogh lived in advance the drama of our time, a time that "now liberates and now enslaves." Nowhere is the study of the artist's correspondence more vital than in the case of Van Gogh. His letters to Theo, in addition to the intrinsic interest they have as deeply moving human documents, are indispensable to a thorough understanding of his concepts and intentions.

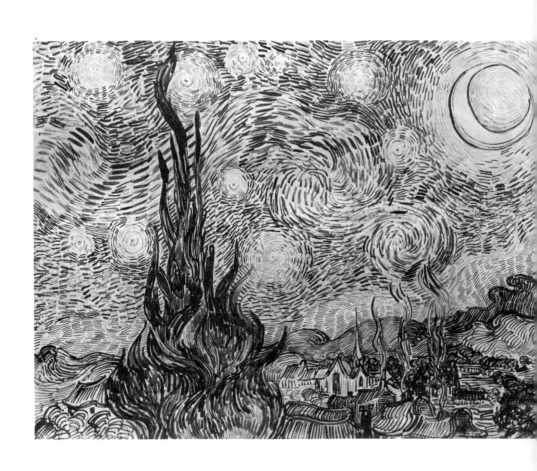

Cypresses by Moonlight. June 1889. Kunsthalle, Bremen

Extracts from the letters of Vincent Van Gogh to his brother Theo, to Emile Bernard, to Van Rappard and Gauguin

"*I intended to keep conscientiously in mind the suggestion to the spectator that these people eating their potatoes under the lamp and putting their hands in the plate, have also tilled the soil, so that my picture praises both manual labour and the food they have themselves so honestly procured. I intended that the painting should make people think of a way of life entirely different from our own civilised one. So I have no wish whatever for anybody to consider the work beautiful or good.*

"*In painting these peasants I thought of what had been said of those of Millet, that they ' seem to have been painted with the very soil they sow' ."*
Letter to Theo

The other, Roots, *represents roots of trees in sandy soil. I have now tried to give the landscape the same feeling as the model, as though clinging to the ground in the same convulsive and passionate manner and yet torn out of it by the gale.*"
Letter to Theo

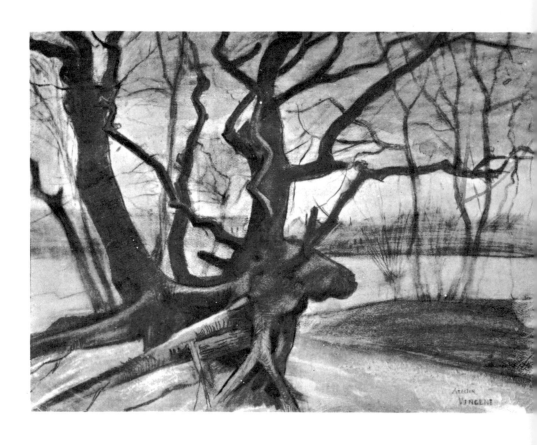

a) Study of Tree. April 1882. Kröller-Müller Rijksmuseum, Otterlo

"*I have to listen to her gossip, as I'm with her all the time, but I don't worry about that. I've never had so much help as from this ugly* [—] *and faded creature. For me she's beautiful and I find in her exactly what I need. Life has marched over her body. Pain and visitations have marked it. Now I can get something out of it.*"

Letter to van Rappard

"*I feel much sympathy for them* [*the charcoal-burners and weavers*] *and should think myself happy if I could draw such characters in such a way as to make them known to a public hitherto practically unaware of them.*

"*The charcoal-burner is the man from the depths,* de profundis; *the other, who looks so dreamy, almost meditative, almost like a sleep-walker, is the weaver.*"

Letter to Theo

"*I feel a strength within me that I must develop, a fire I can't put out, but must stir up, though I don't know where it will lead me and I shouldn't be surprised if it brought me to a bad end.* ... *In certain situations it's better to be conquered than conqueror, more Prometheus than Jupiter.*"

Letter to Theo

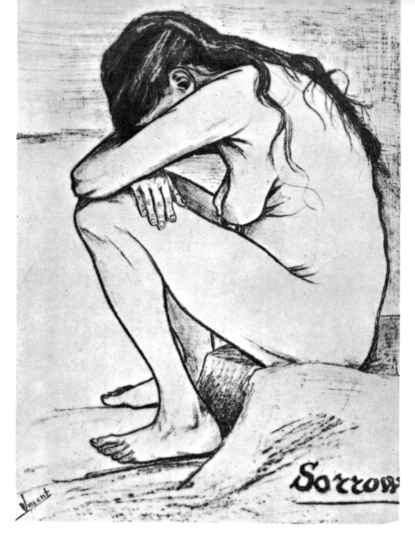

b) Sorrows, lithograph. November 1882.
Vincent Van Gogh Rijksmuseum, Amsterdan.

*"As for work, I brought back a 24" × 12" canvas to-
day. It's a drawbridge with a small cart crossing it,
against a blue sky. The stream's also blue, the banks
orange and green, with a group of washerwomen in
blouses and gaily striped headdresses."*
Letter to Theo

*"Here's another landscape, sunset or moonrise, but
summer sun anyhow. Violet town, yellow star,
bluish-green sky. All the cornfields have tones of
old copper, gold-green or red, golden-yellow, bronze-
yellow, greenish-red. A No. 30 square canvas. I
painted it in a strong mistral with my easel plugged
into the ground with iron pegs, a tip I can recom-
mend. You push the feet of the easel into the
ground with iron pegs 20 inches long beside them.
Tie the whole thing up with string. Then you can
work in the wind."*
Letter to E. Bernard

*"The Mediterranean is the colour of mackerel, that is
to say, it varies. One can't always say it's blue,
because a second later the reflection changes to pink
or grey."*
Letter to Theo

*"These are views, from a rocky hill, of the Crau, which
produces an excellent wine, the town of Arles and
the Fontvieilles country. Contrast of wild, romantic
foreground and distant perspective, wide and peaceful,
in horizontal lines falling gradually to the foot of the
Alps.*

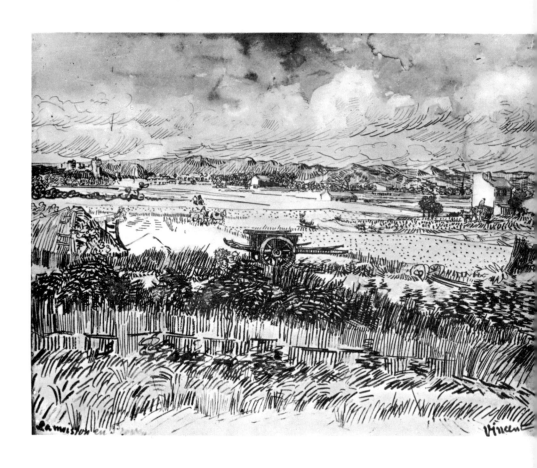

c) Harvest in Provence. June 1888. Private collection

"I believe myself that the two views of the Crau and the country extending to the Rhone are the best pen work I've done. If by any chance Thomas wants them, he can't have them for less than 100 francs each. It's not everyone who would have the patience to be eaten up by mosquitoes and fight the maddening perversity of this endless mistral, to say nothing of spending whole days out of doors with nothing but a little bread and milk, as it's too far to be always going backwards and forwards to the town."
Letter to Theo

"A Socratic type and no less so for being rather fond of liquor and possessing a high colour scheme. His wife had just given birth and the worthy fellow was beaming with satisfaction. He's as ferocious a republican as old Tanguy. ... He was too stiff in the pose, so I painted him twice, the second time at one sitting."
Letter to E. Bernard

"I'm painting just now with the rapture of a Marseillais *eating* bouillabaisse, *which won't surprise you when you hear that the subject is big sunflowers. ... I'm working on them every morning, starting at daybreak, for they fade quickly and I've got to do the whole thing right off."*
Letter to Theo

"In my picture of an all-night café I've tried to suggest that it's a place where you can be ruined, go mad and commit crimes. In short, by contrasting soft rose and the red of blood and wine-dregs, mellow Louis Quinze

and Veronese greens with greenish-yellow and hard blue-greens, in a hellish, sweltering atmosphere of pale saffron, I aimed at something like the powers of darkness in a low drinking-den, lurking under the appearance of Japanese gaiety and Tartarinesque good humour."

Letter to Theo

"This picture raises the eternal question whether we can see the whole of life or only know a hemisphere of it before death. I've no idea of the answer myself. But the sight of stars always sets me dreaming just as naïvely as those black dots on a map set me dreaming of towns and villages. Why should those points of light in the firmament, I wonder, be less accessible than the dark ones on the map of France? We take a train to go to Tarascon or Rouen and we take death to go to a star. What is certainly true about this argument is that as long as we're alive we can't visit a star any more than when we are dead we can take a train. Anyhow, I don't see why cholera, the stone, phthisis and cancer should not be heavenly modes of locomotion like ships, buses and trains here below, while if we die peacefully of old age we make the journey on foot."

Letter to Theo

"As there's nothing against it — assuming that in the innumerable other planets and suns, lines, shapes and colours also exist — we may keep a comparatively open mind about the possibilities of painting on a higher, different level of existence, the difference being due to causes which may be no more malignant and surprising

than the transformation of a grub into a butterfly or a cockchafer. The painter-butterfly might have one of the innumerable stars to work in. They might be no more inaccessible to us after death than are the black dots on the map, standing for towns and villages, in our terrestrial life.

"Science, by which I mean scientific reasoning, looks to me like an instrument which will one day take us very far. For instance, at one time the earth was supposed to be flat. Well, so it is, even to-day, from Paris to Asnières. But that fact doesn't prevent science from proving that the earth as a whole is spherical. No one nowadays denies it. Well, nowadays, in spite of that, we are still at the stage of believing that life itself is flat, the distance from birth to death. Yet the probability is that life, too, is spherical and much more extensive and capacious than the hemisphere we know at present."

Letter to E. Bernard

"I'm working on a canvas of pinks over a bright green background and two others of big bunches of violet irises, one being set against a pink background, with a harmonious, mellow effect due to the combination of greens, pinks and violets. The other bunch, on the contrary, of violet shading into carmine and pure Prussian blue, is thrown into relief by a brilliant lemon-yellow background, other yellow tones appearing in the vase and the base on which it stands. Here the violently opposed complementaries are intensified in their effect by their very antagonism."

Letter to Theo

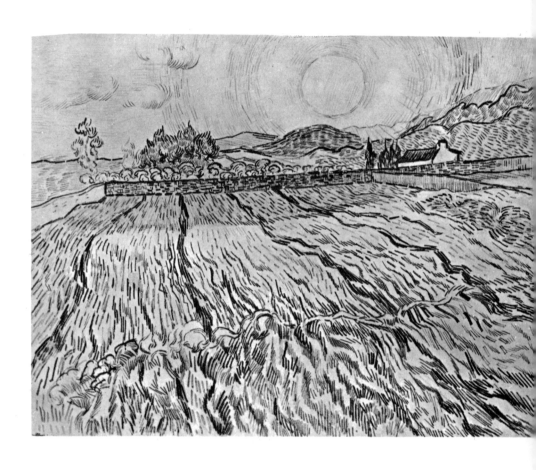

d) Walled Field (Seen from the Asylum at St. Rémy). 1889-1890. Neue Staatsgalerie, Munich

"*I've done ... a canvas of my bedroom. It has deal furniture, as you know. It amused me enormously to paint the bare, Seurat-like simplicity of such an interior. The colours are flat but laid on in rough impasto, the walls, pale lilac, the floor in broken, faded reds, the chairs and bedstead chrome yellow, with the pillows and sheet a very pale lemon green, the coverlet blood-red, while the dressing-table is orange, the wash-basin blue and the window green. I wanted to suggest absolute repose, you see, by all these disparate tones, the only touch of white being provided by the black-framed mirror, this passage constituting the fourth pair of complementaries in the painting.*"

Letter to Gauguin

"*It is said, and I can well believe it, that it is difficult to know oneself. But it isn't easy, either, to paint oneself. So I am working on two portraits of myself at this moment, since I have no other model and it is high time I paid a little attention to the face. One of the portraits was begun as soon as I got up. I was thin, and devilish pale.*

"*I used deep blue violet, making the head whitish, with yellow hair, so that a certain effect of coulour is obtained. ...*"

Letter to Theo

PLANCHES

PLATES

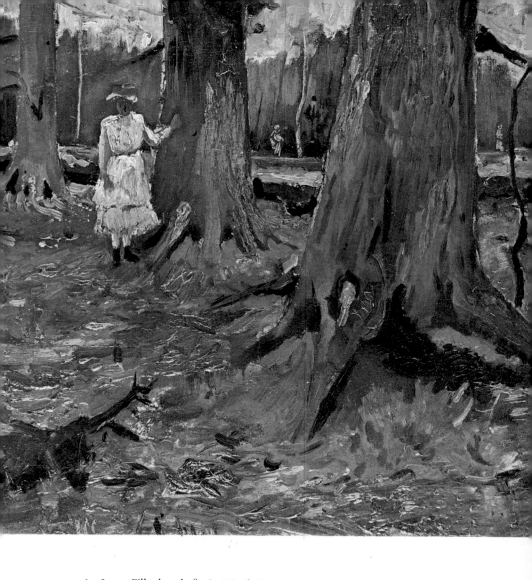

1 Jeune Fille dans la forêt. Détail. September 1882. Girl in Forest.

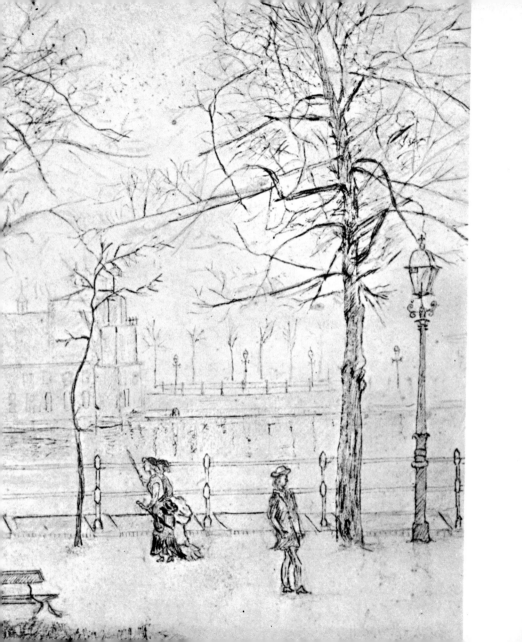

2 Au bord d'un canal. 1880-1881. Canal Bank.

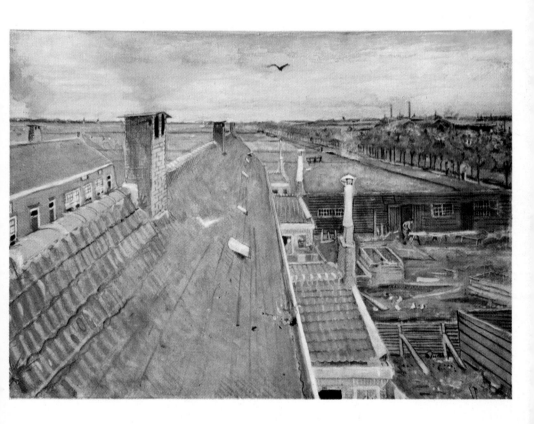

3 Les Toitures. Juillet 1882. The Roofs.

4 Le Métier à tisser. Mai 1884. The Loom.

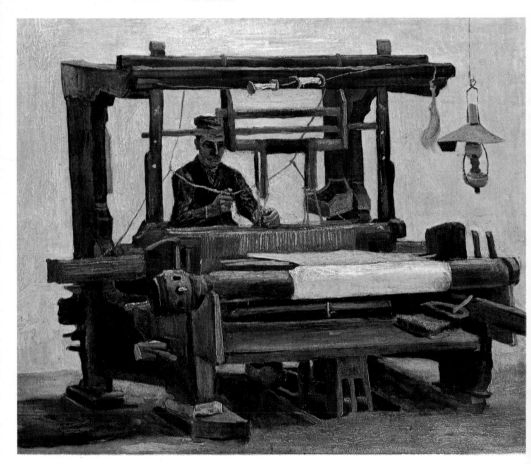

5 La Paysanne au bonnet blanc. Mai 1885. Peasant Woman in a White Bonnet.→

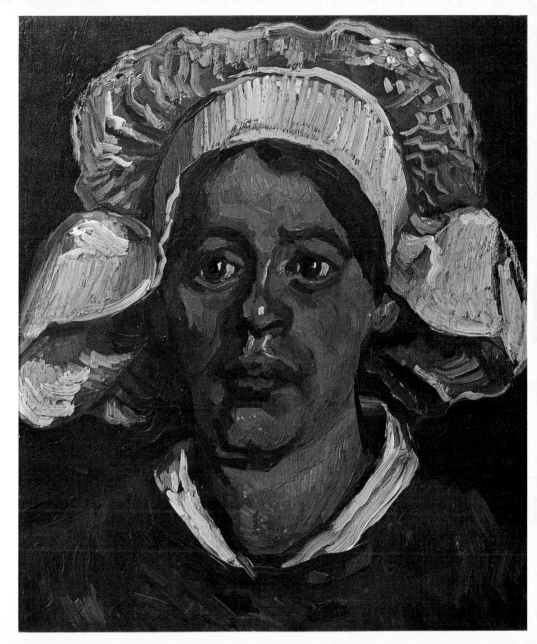

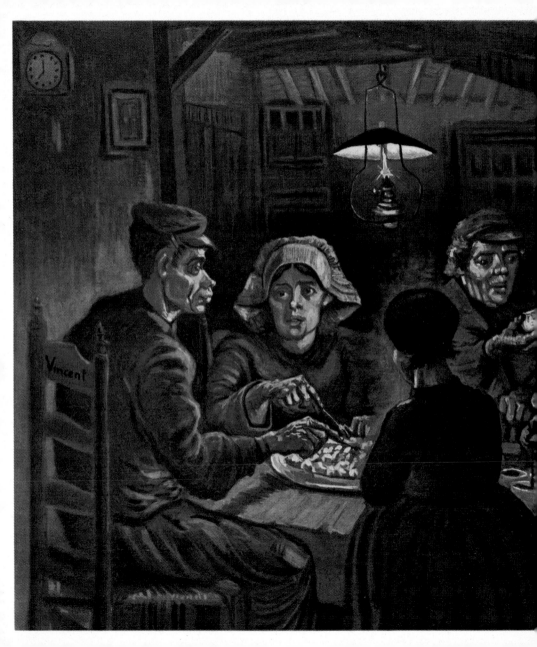

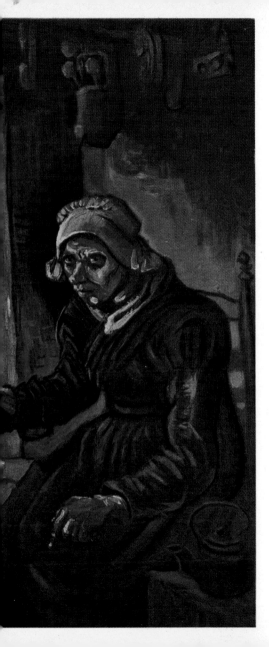

6
Les Mangeurs de pommes de terre.
Avril-mai 1885.
The Potato Eaters.

7 La chaumière. Juin-juillet 1885. Thatched Cottage.

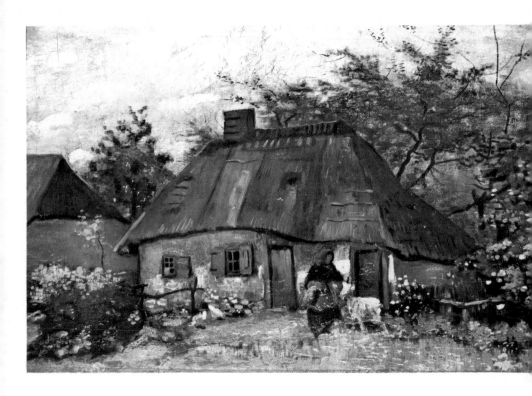

8 Le Quai. Détail. Décembre 1885.–

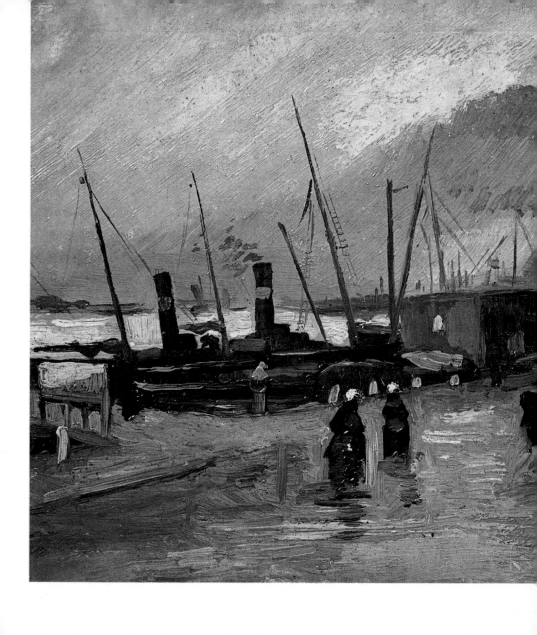

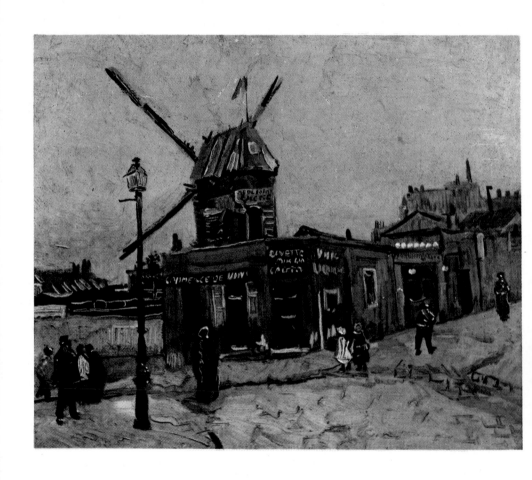

9 Le Moulin de la Galette vu de la rue Girardon. Printemps 1886.

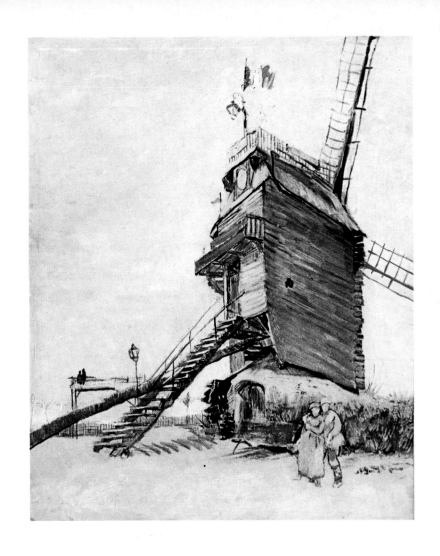

10 Le Moulin de la Galette. Hiver 1886-1887.

11 Le Restaurant de la Sirène. Début de l'été 1887.

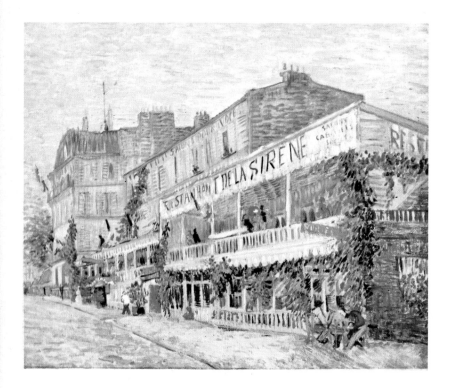

12 Nature morte : fleurs. Détail. Été 1887. Still Life : Flowers.→

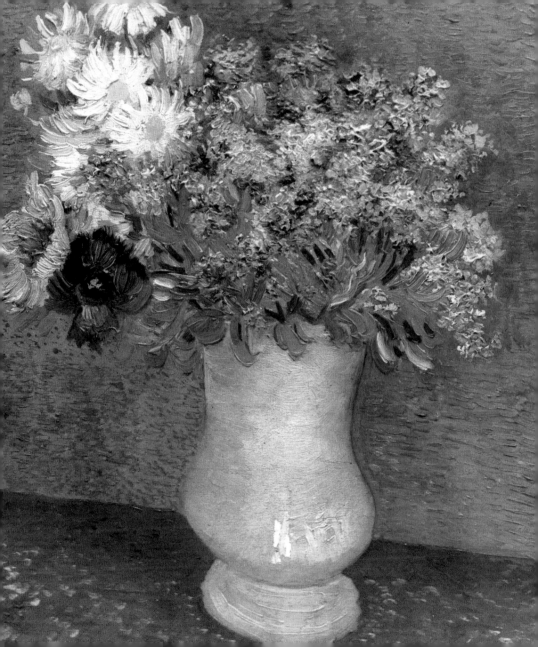

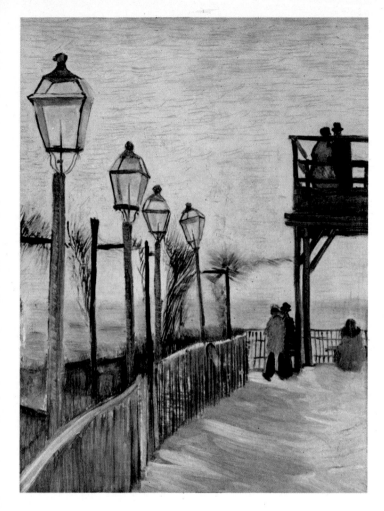

13
La Terrasse
du Moulin
de la Galette.
Hiver 1886-1887.
Montmartre.
The Street Lamps.

14 Vue sur Paris de la chambre de Vincent, rue Lepic. Début du printemps 1887.
View from Van Gogh's Room, Rue Lepic.→

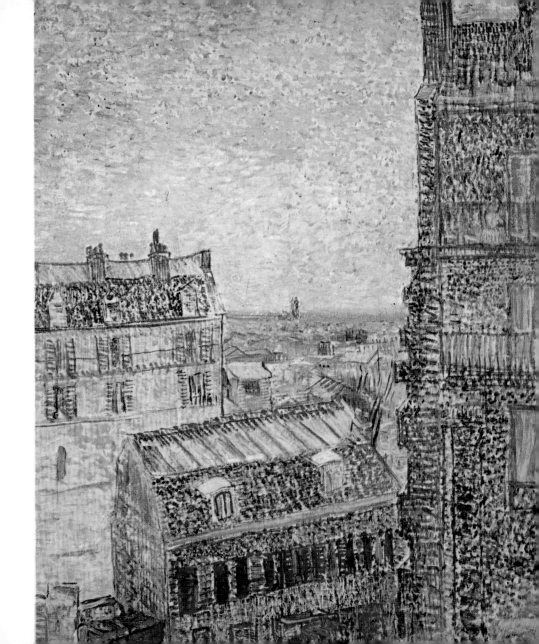

15 Vieux Souliers aux lacets. Fin 1886. Old Boots with Laces.

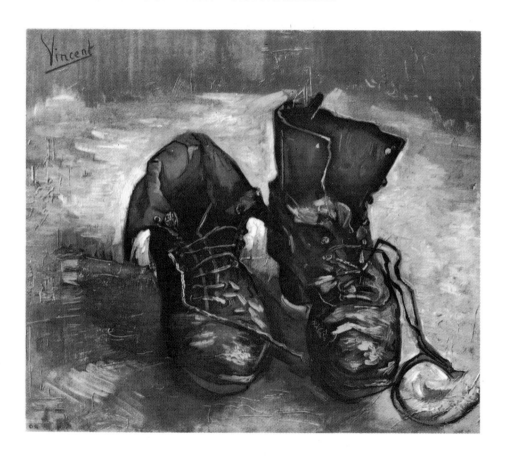

16 Le Père Tanguy. Automne 1887.→

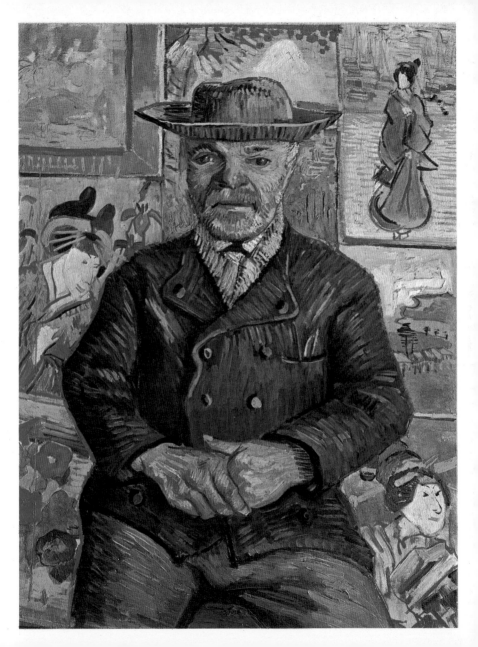

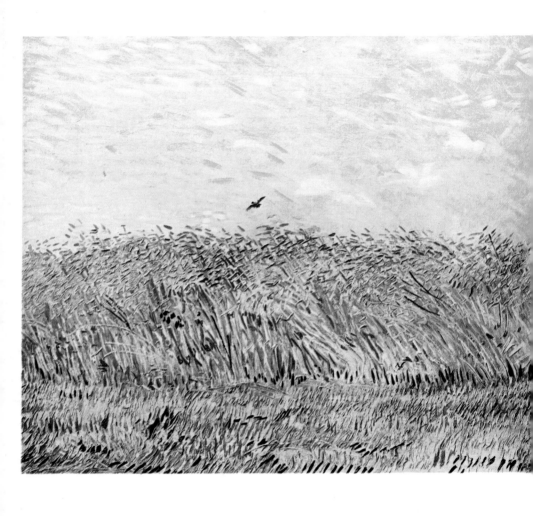

17 Champ de blé à l'alouette. Été 1887. Cornfield with Lark.

18
Fleurs dans un vase bleu.
Été 1887.
Flowers in Blue Vase.

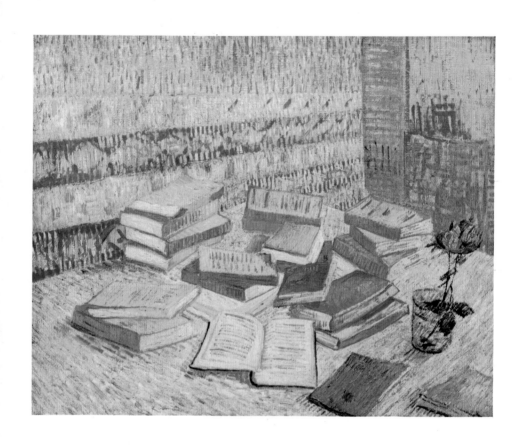

19 Les Livres jaunes (romans parisiens). Automne 1887. The Yellow Books (Parisian Novels).

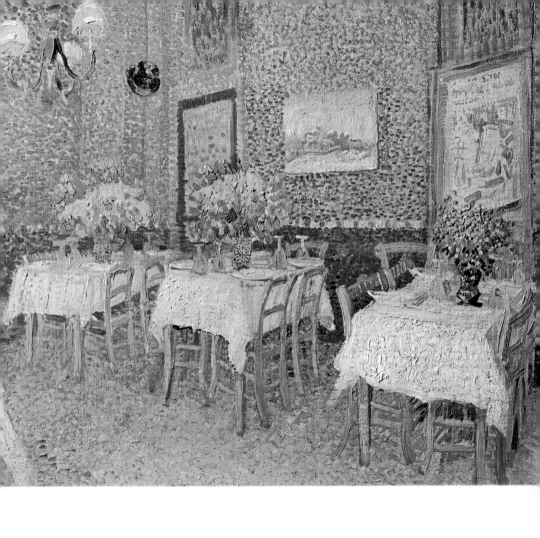

20 Intérieur de restaurant. Été 1887. Restaurant Interior.

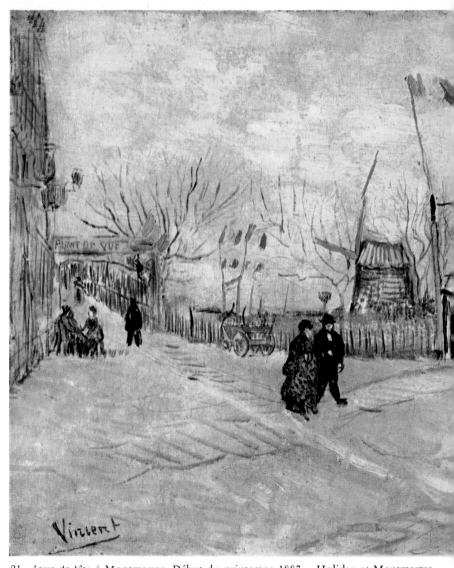

21 jour de fête à Montmartre. Début du printemps 1887. Holiday at Montmartre.

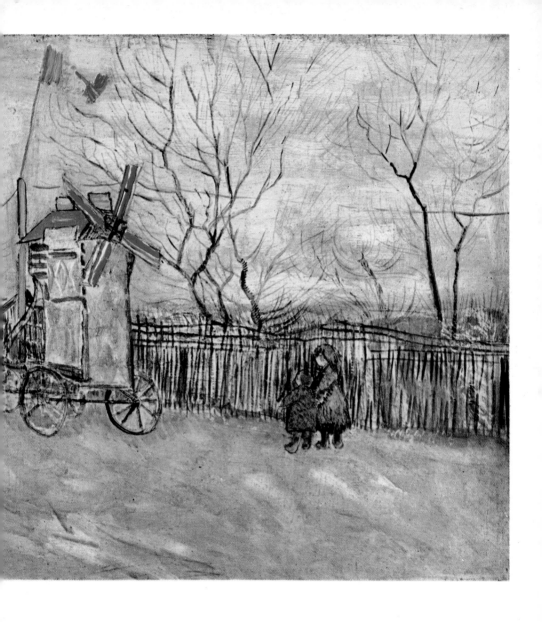

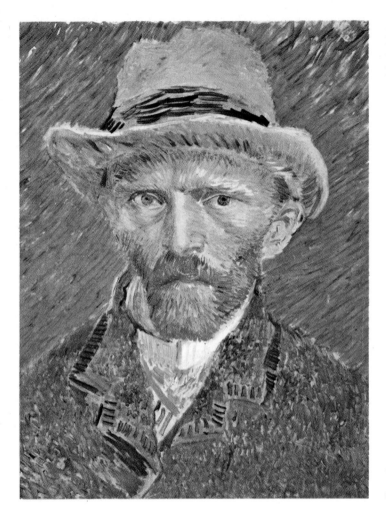

22
Portrait
de l'artiste
par lui-même.
Été 1887.
Self-portrait
in a Grey Hat.

23→
La Femme
« au Tambourin ».
Février 1887.
The Woman
at « le Tambourin ».

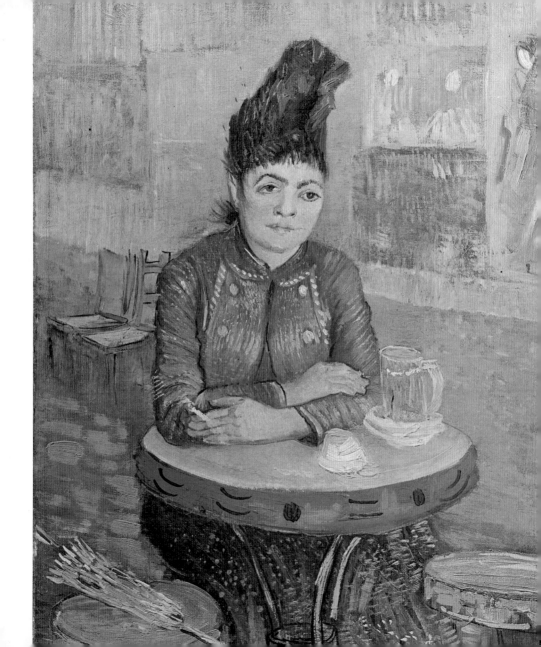

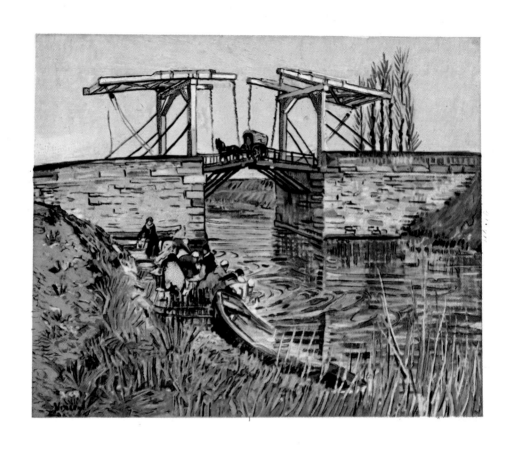

24　Le Pont de l'Anglois. Mars 1888.

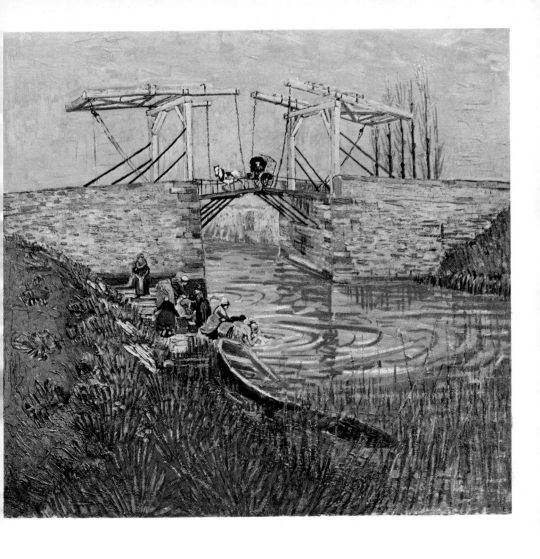

25 Le Pont de l'Anglois. Avril 1888.

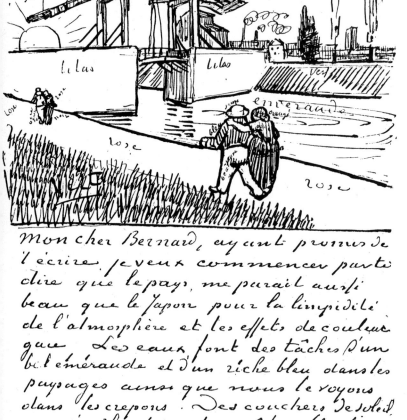

jaune

lilas lilas vert

emeraude orange

rose

rose rose

Mon cher Bernard, ayant promis de
t'écrire, je veux commencer par te
dire que le pays me paraît aussi
beau que le Japon pour la limpidité
de l'atmosphère et les effets de couleur
gais. Les eaux font des tâches d'un
bel émeraude et d'un riche bleu dans les
paysages ainsi que nous le voyons
dans les crépons. Des couchers de soleil
orangé pâle faisant paraître bleu les
terrains. Des soleils jaunes splendides.
Cependant je n'ai encore guère vu le
pays dans sa splendeur habituelle d'été
Le costume des femmes est joli et le dimanche
surtout on voit sur le boulevard des
arrangements de couleur très naïfs et
bien trouvés. Et cela aussi sans doute
s'égayera encore en été

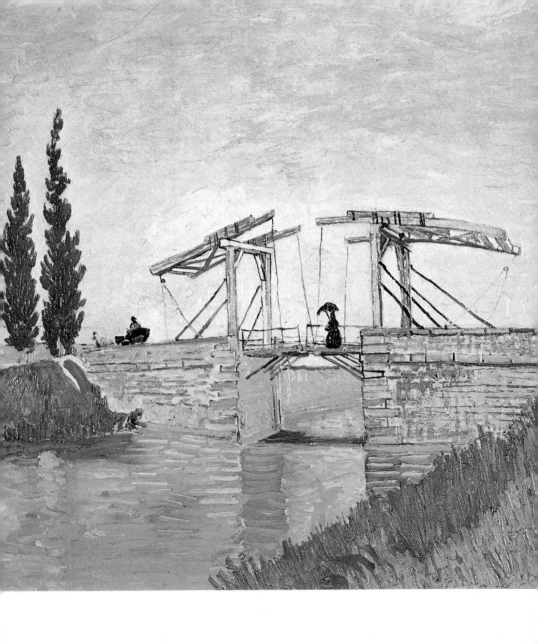

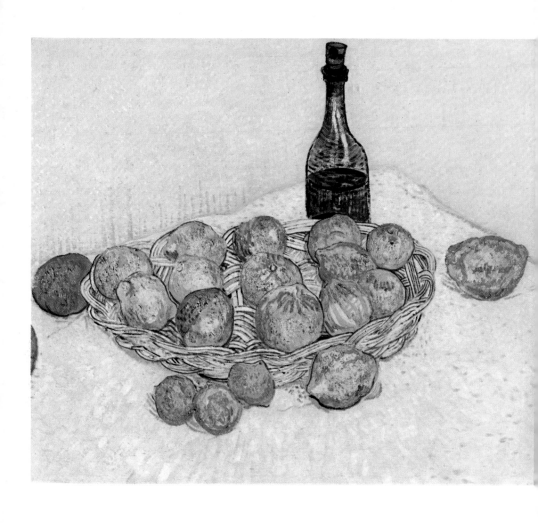

28 Nature morte aux citrons. Mai 1888. Still Life with Lemons.

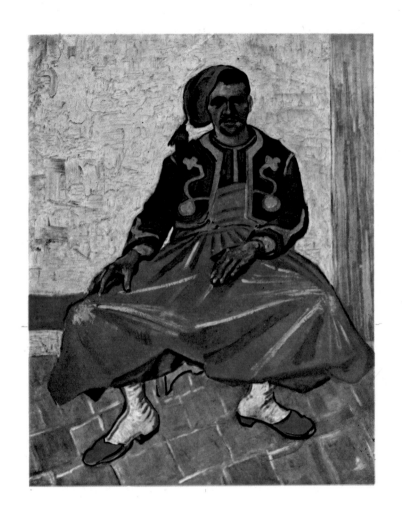

29 Le Zouave. Juin 1888.

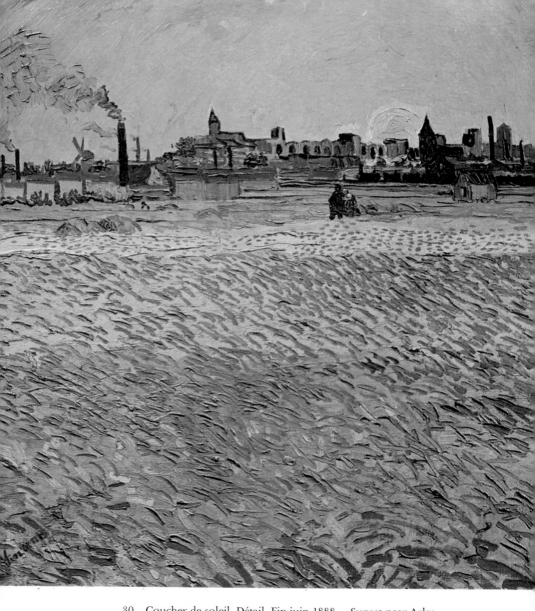

30 Coucher de soleil. Détail. Fin juin 1888. Sunset near Arles.

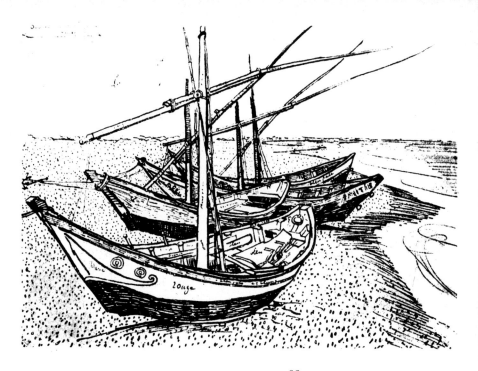

32
Barques sur la plage.
Juin 1888.
Boats at Les Saintes-Maries.

31
Mas au bord de la mer.
1888.
Farmhouses on the Seacoast.

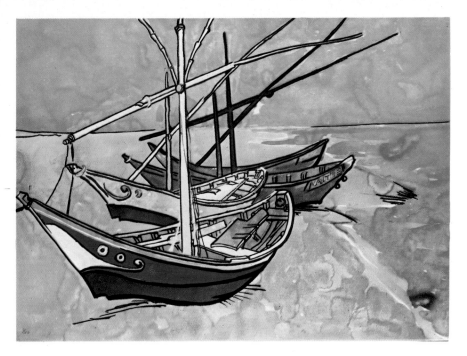

33 Barques sur la plage. Juin 1888. Boats at Les Saintes-Maries.

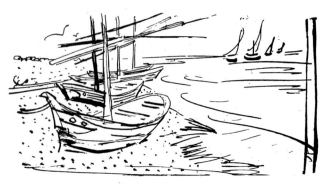

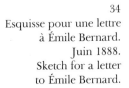

34
Esquisse pour une lettre
à Émile Bernard.
Juin 1888.
Sketch for a letter
to Émile Bernard.

35 Barques sur la plage, Saintes-Maries-de-la-Mer. Juin 1888. Boats on the Beach.

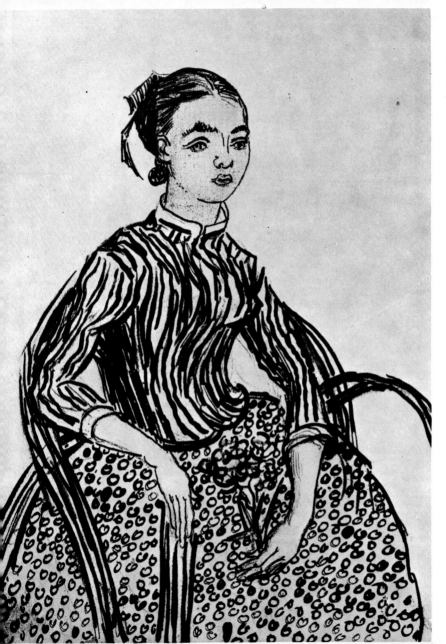

36
La Mousmée.
Juillet-août
1888.

37→
La Mousmée.
Juillet 1888.

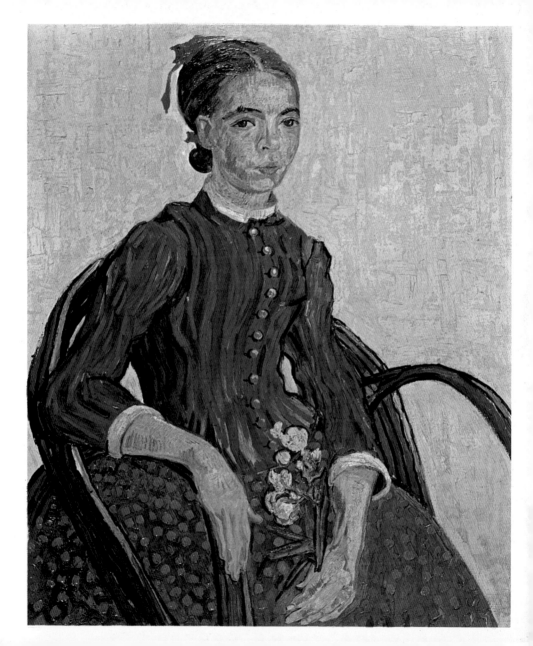

38
Le Jardin du Poète.
Septembre 1888.

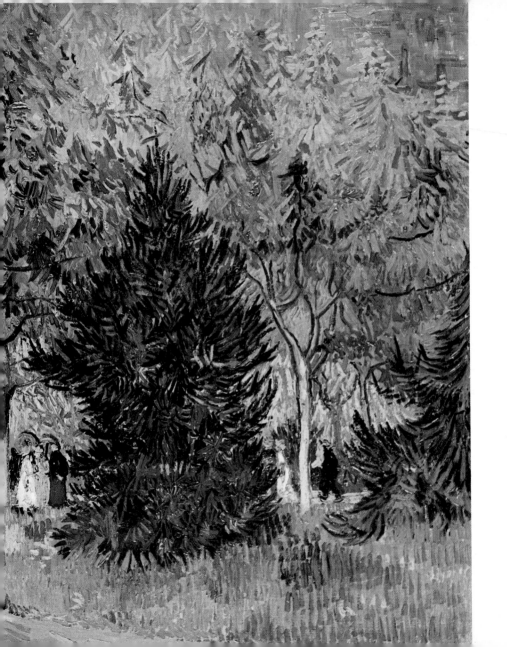

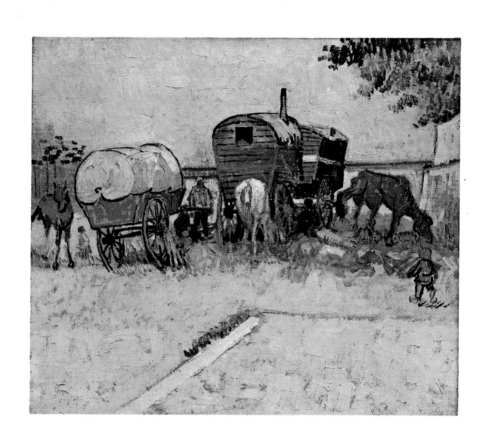

39 Les Roulottes. Août 1888. Gypsy Camp.

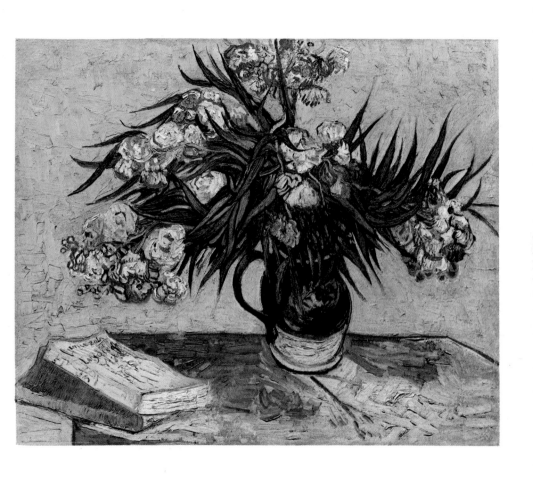

40 Les Lauriers roses. Août 1888. Oleanders.

41
Vieux Paysan provençal.
Août 1888.
Old Provençal Peasant.

42→
Tournesols. Août 1888.
Sunflowers.

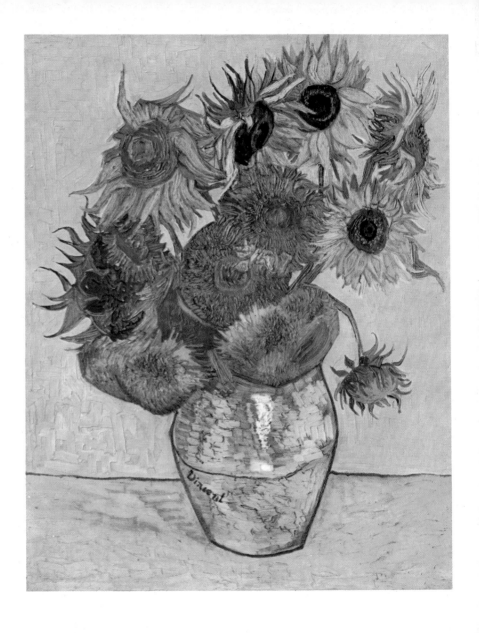

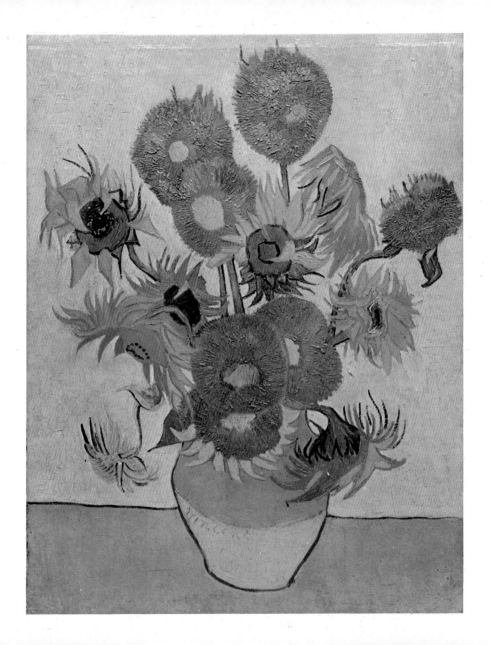

-43 Tournesols. Août 1888. Sunflowers.

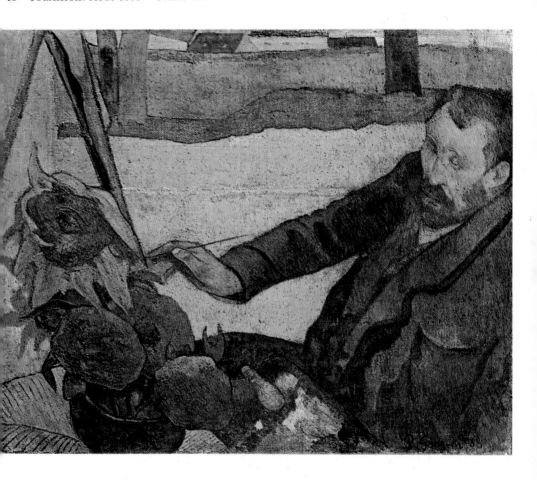

44 Gauguin : Van Gogh peignant des tournesols. 1888. Van Gogh painting Sunflowers.

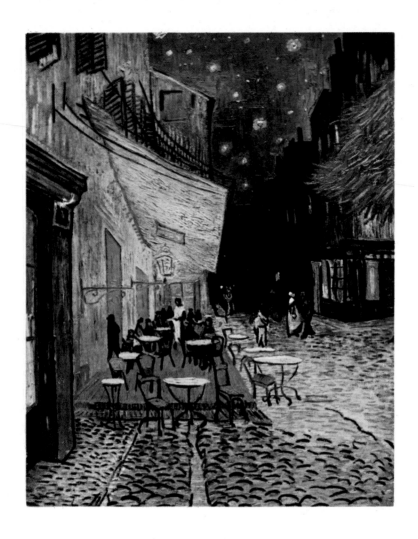

45 Le Café, le soir. Septembre 1888. Café at Night.

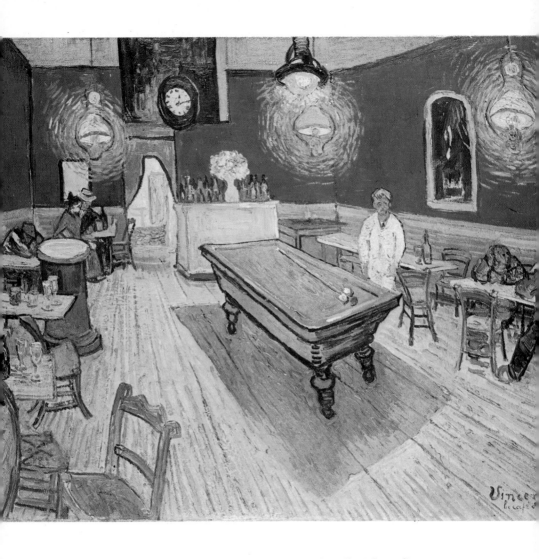

46 Le Café de nuit. Septembre 1888. The All Night Café.

47 Les Bateaux amarrés. Août 1888. Moored Boats.

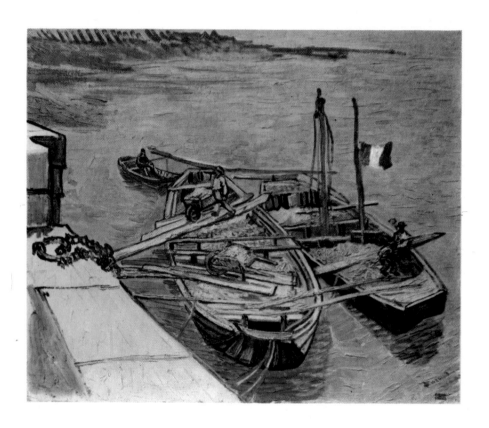

48→
Le Jeune Homme à la casquette.
Octobre-novembre 1888.
Young Man with Cap.

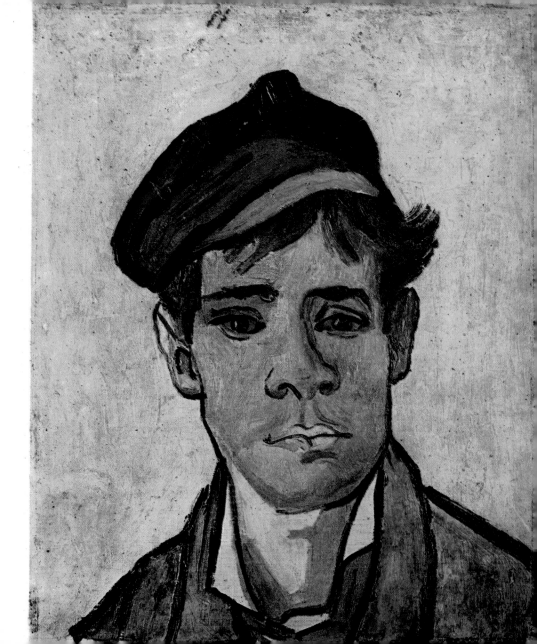

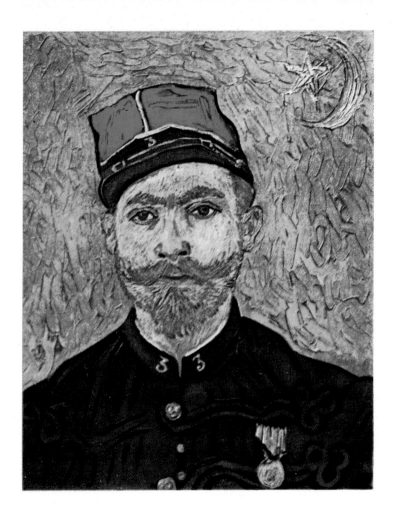

49 Portrait du sous-lieutenant Milliet. Septembre-octobre 1888.

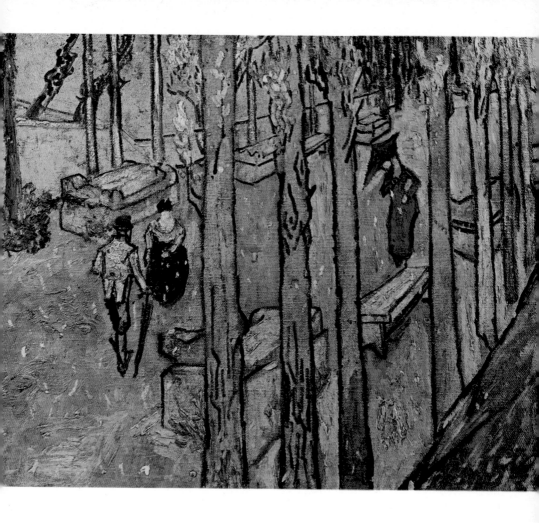

50 Les Alyscamps. Novembre 1888. Les Alyscamps in Autum.

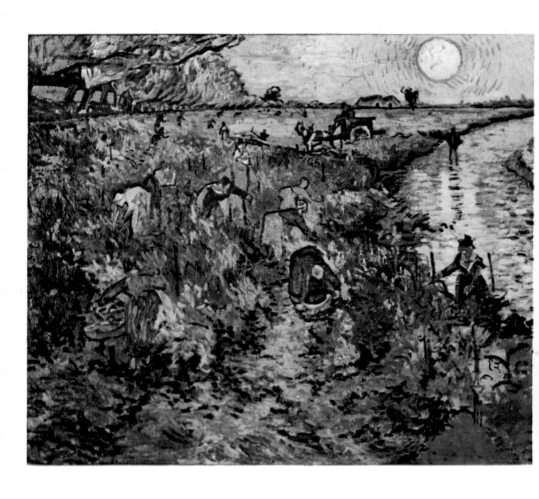

51 La Vigne rouge. Novembre 1888. Red Vineyard.

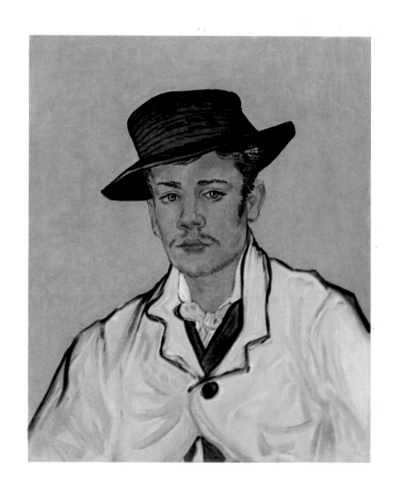

52 Portrait d'Armand Roulin. Novembre 1888.

53
La Chambre à coucher à Arles.
Octobre 1888.
Van Gogh's Room at Arles.

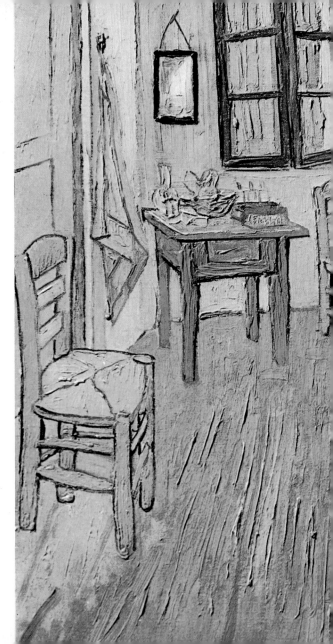

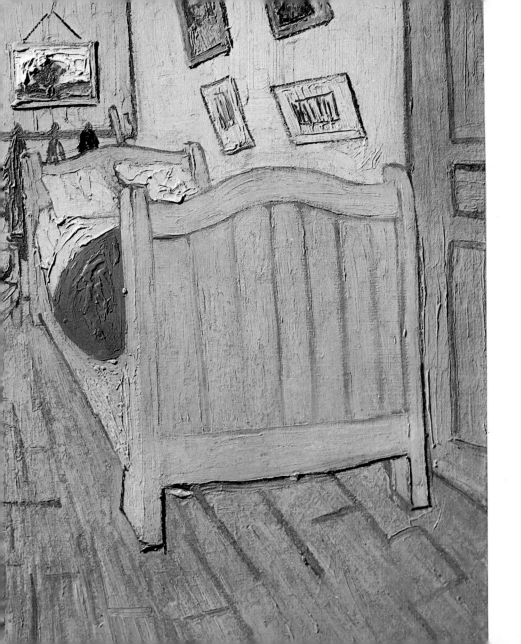

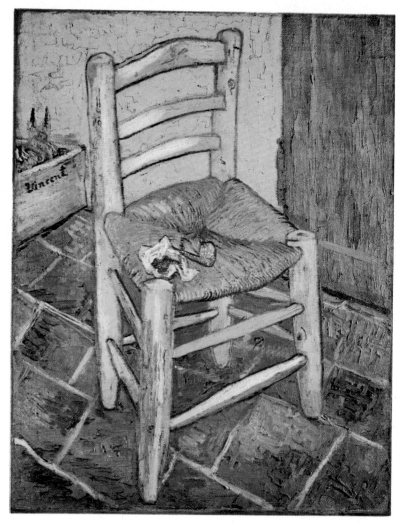

54
La Chaise
de Vincent.
Décembre 1888-
janvier 1889.
Vincent's Chair.

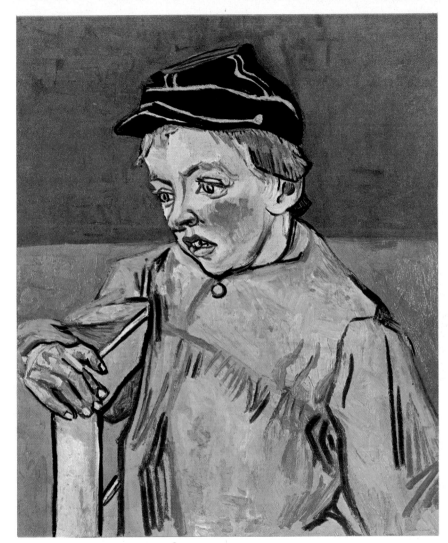

55
Le Collégien.
Janvier 1890.
Schoolboy.

56 Vue d'Arles. Avril 1889. View of Arles.

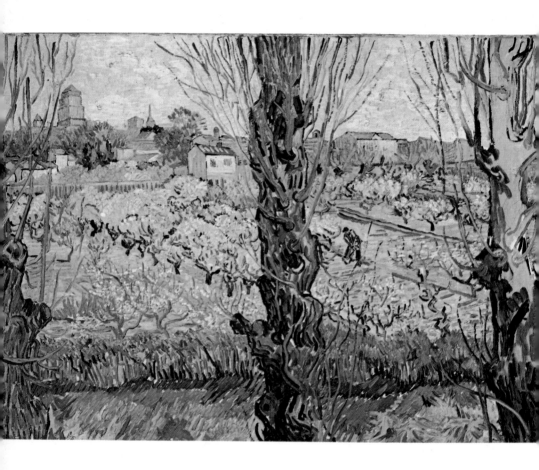

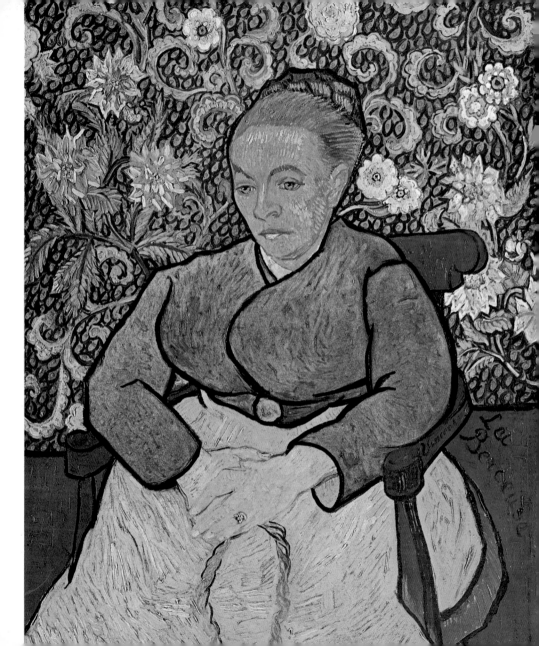

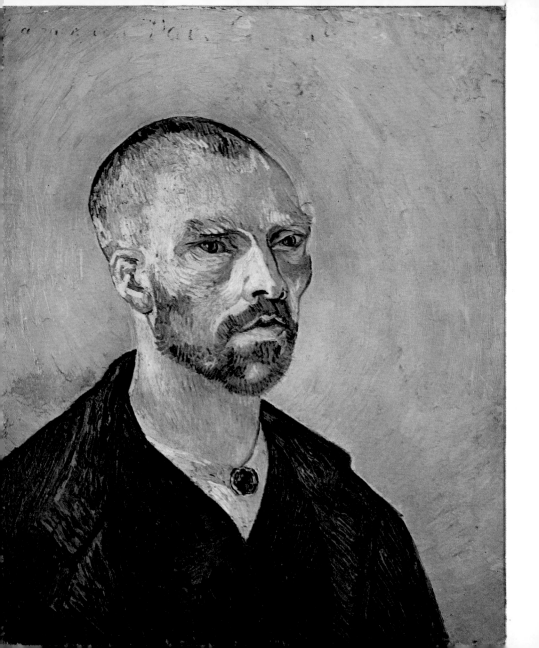

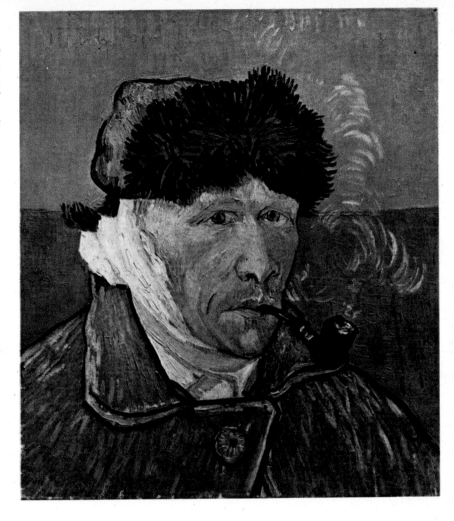

59
Portrait à
l'oreille coupée.
Janvier-février
1889.
Self-portrait
with Severed Ear.

58 Portrait de l'artiste par lui-même. Septembre 1888. Self-portrait.

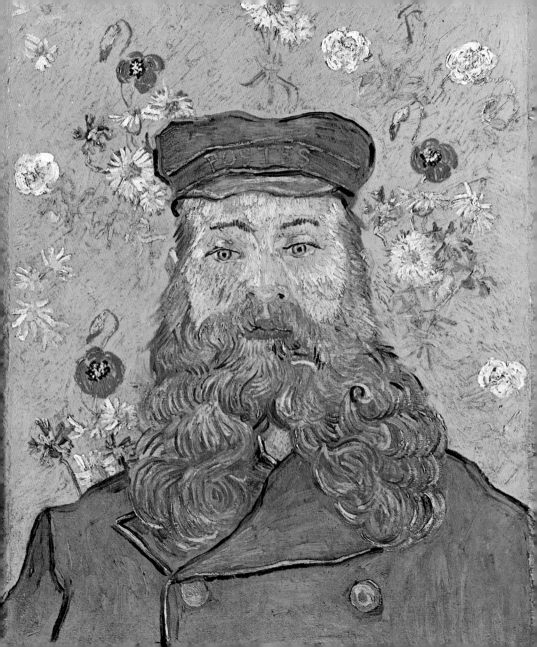

61　Portrait de l'artiste par lui-même. Septembre 1889. Self-portrait.

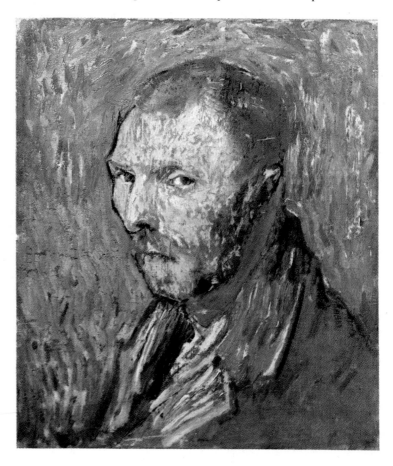

←60　Le Facteur Roulin. Février-mars 1889.　The Postman Roulin.

62 Les Blés jaunes. Juillet 1889. Cornfield and Cypress.

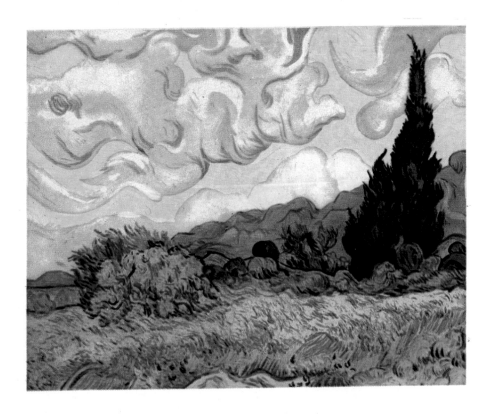

63 Le Jeune Paysan. Mai-juin 1889. Young Male Peasant.→

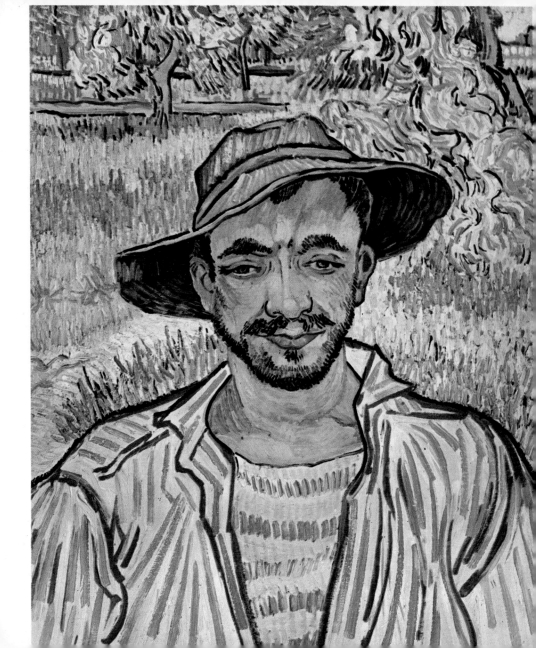

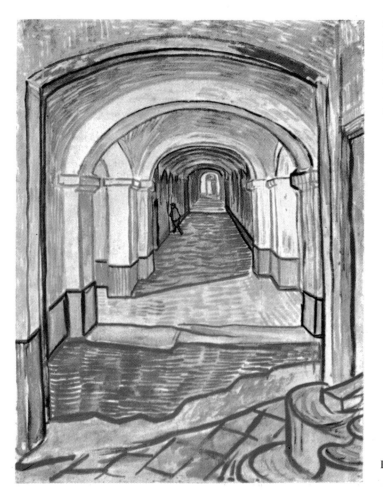

64
Le Couloir de
l'asile Saint-Paul.
Mai-juin 1889.
Corridor in the
Asylum Saint-Paul
at St-Remy.

65→
Portrait de l'artiste.
Détail. Septembre 1889.
Self-portrait.

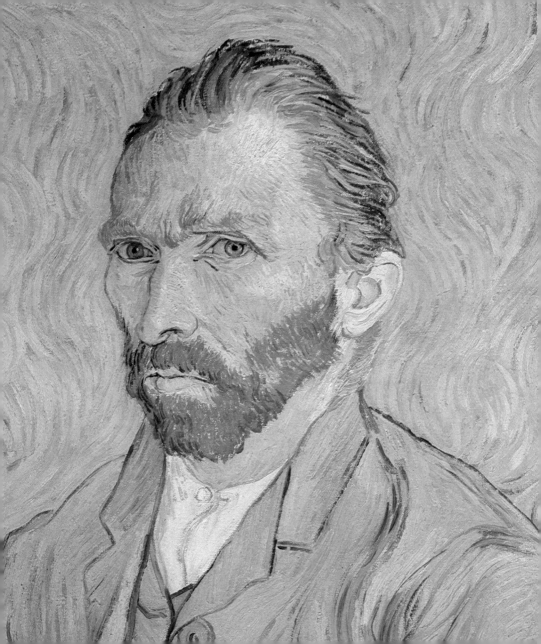

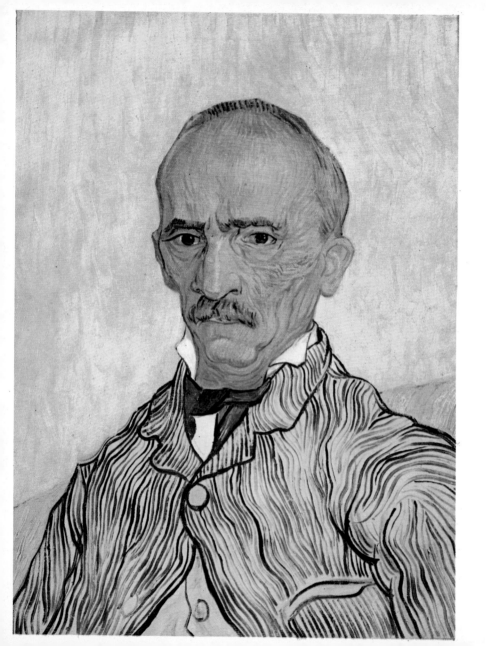

Le Surveillant en chef
de l'asile Saint-Paul.
Septembre 1889.
Chief Superintendent
of St-Paul's Asylum.

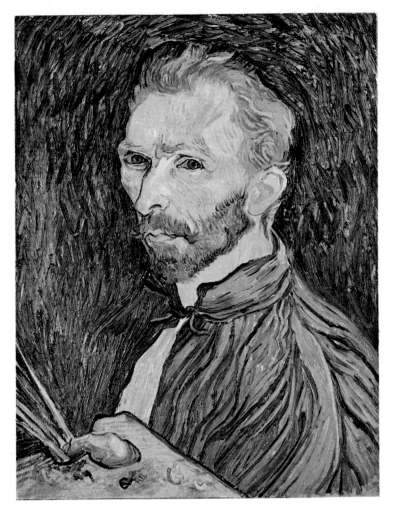

67 Portrait de l'artiste à la palette. Septembre 1889.
 Self-portrait with Palette.

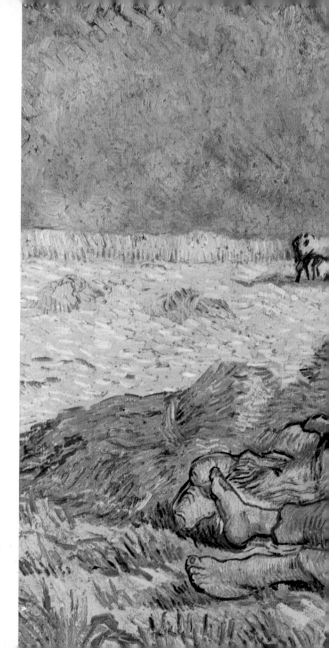

68
La Méridienne (d'après Millet).
Janvier 1890.
The Nap (after Millet).

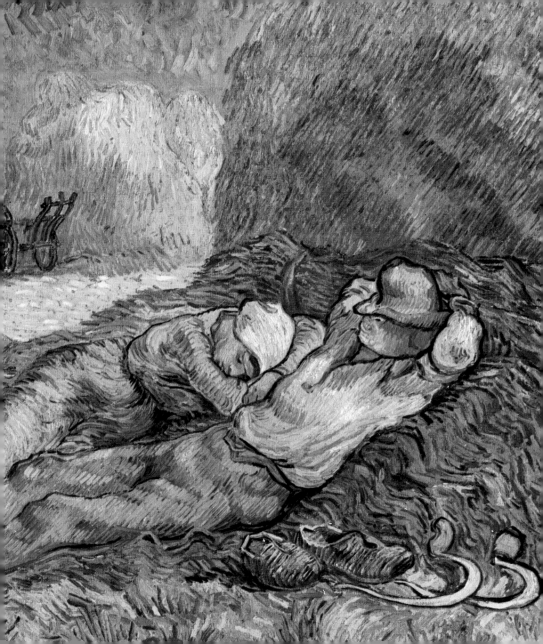

69 La Nuit étoilée. Juin 1889. Starry Night.

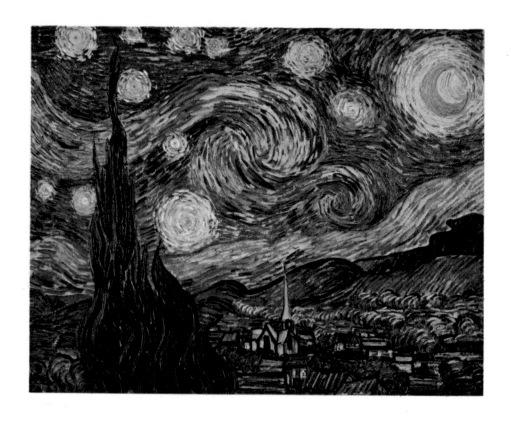

70 Au seuil de l'Éternité. Mai 1890. The Threshold of Eternity.→

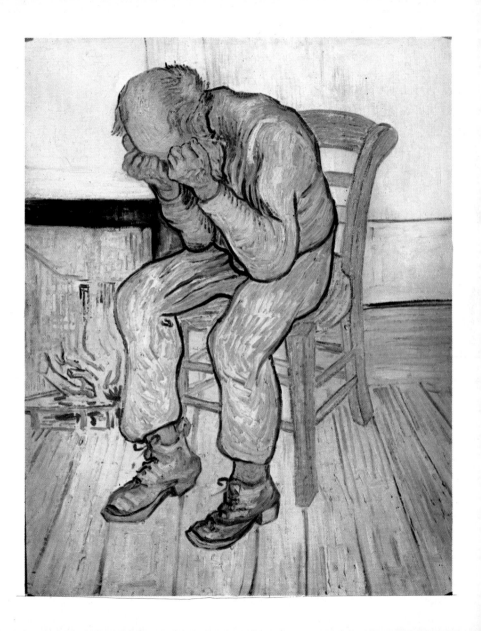

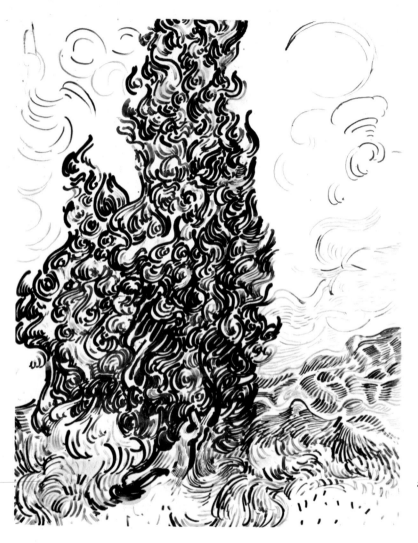

71
Les Cyprès.
Juin 1889.
Cypresses.

72→
La Route
aux cyprès.
Mai 1890.
Road with
Cypresses.

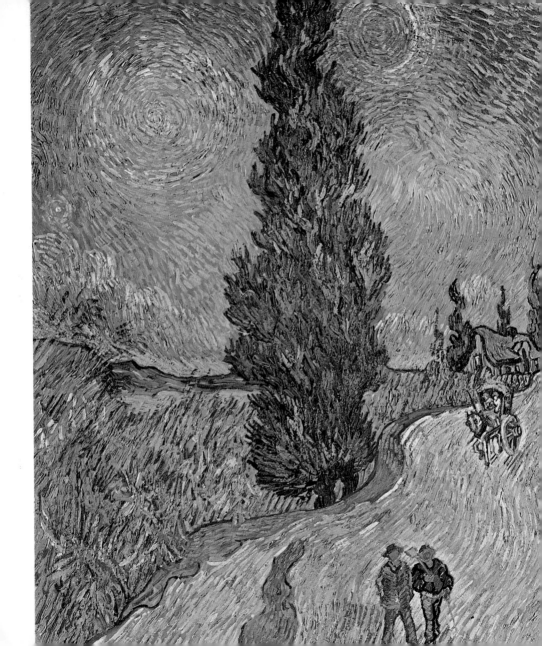

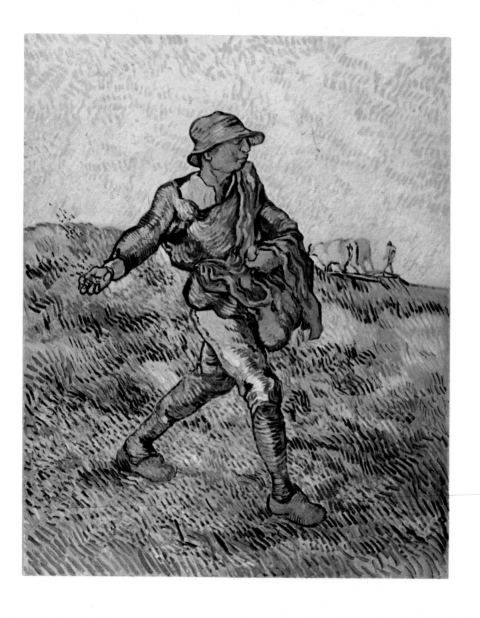

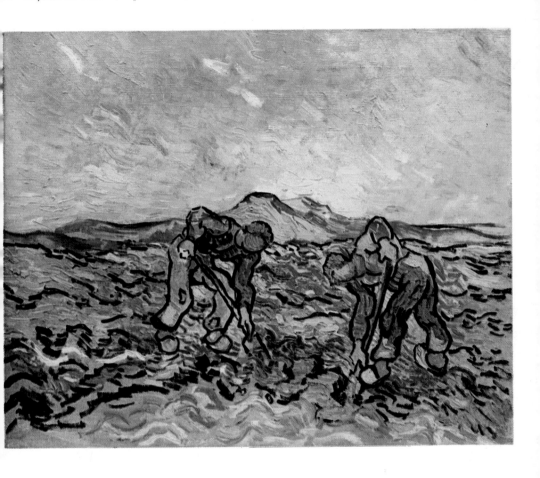

-73 Le Semeur (d'après Millet). Novembre 1889-janvier 1890. The Sower (after Millet).

75 Vue des Alpilles. Mars-avril 1890. At the Foot of the Alpilles.

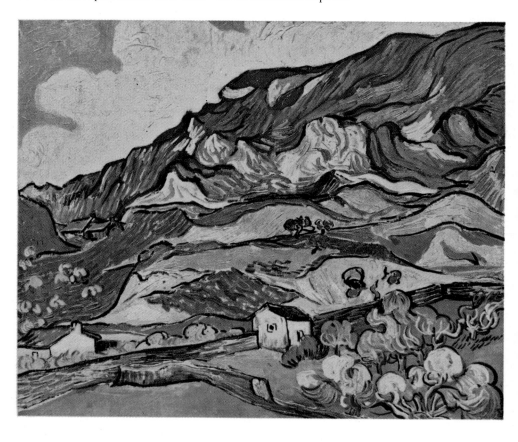

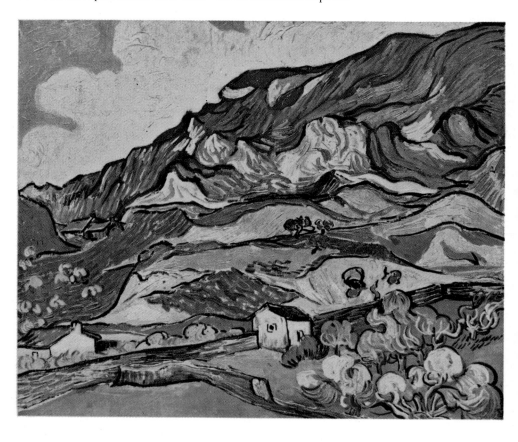

76→
L'Arlésienne. Janvier-février 1890.

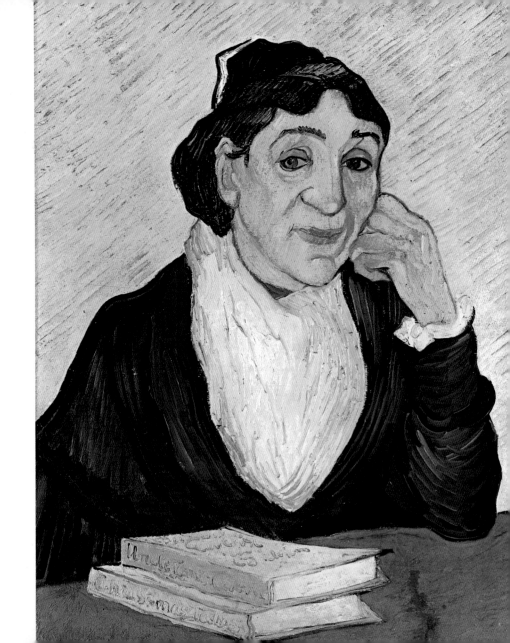

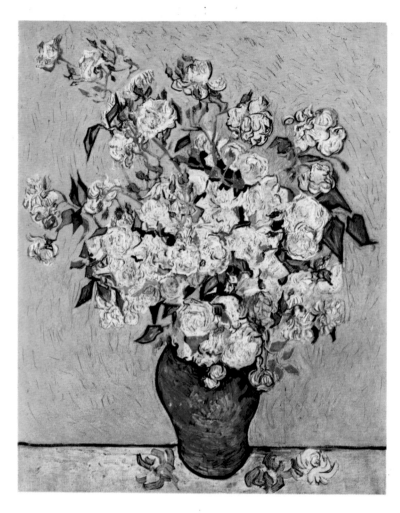

77 Les Roses blanches. Mai 1890. White Roses.

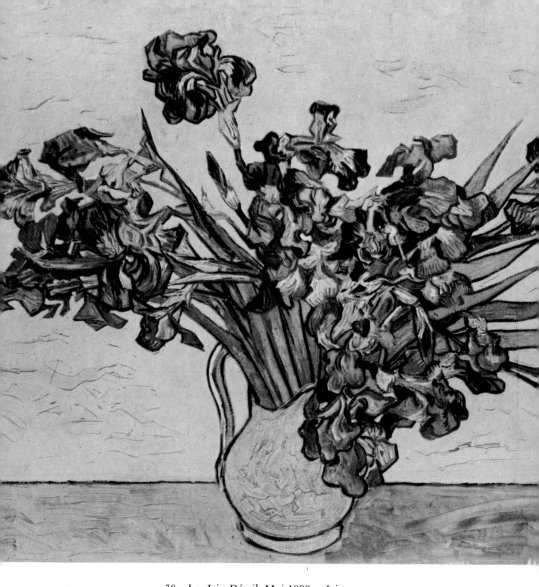

78 Les Iris. Détail. Mai 1890. Irises.

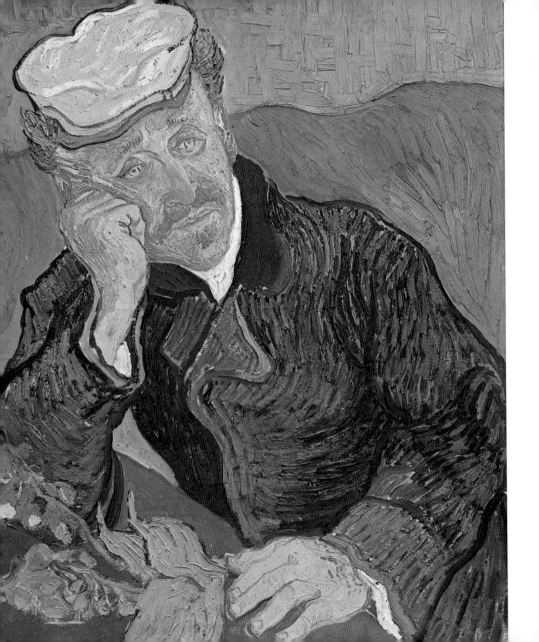

80 Paysage à Auvers. Juin 1890. Road near Auvers.

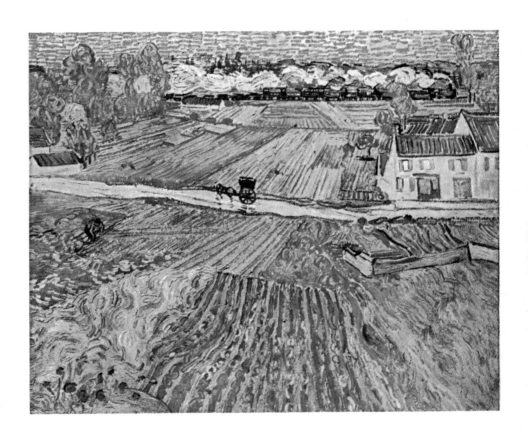

←79 Le Docteur Gachet. Juin 1890.

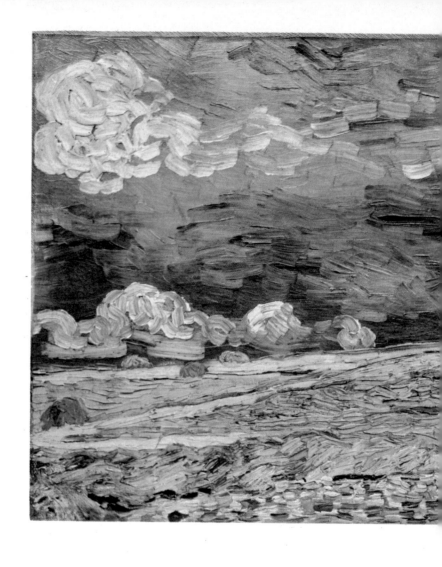

81 Champs sous ciel bleu. Juillet 1890. Field and Blue Sky.

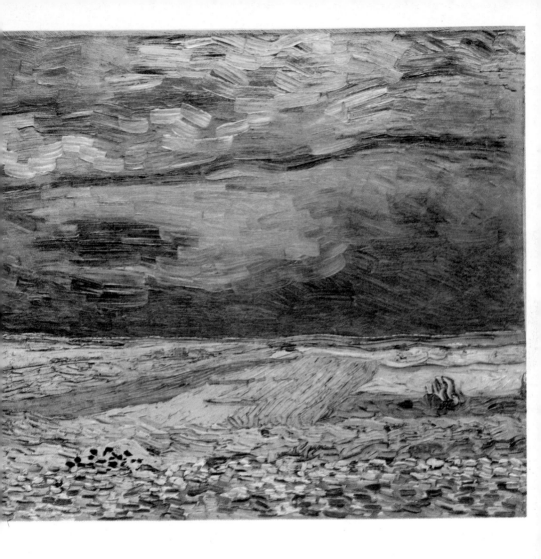

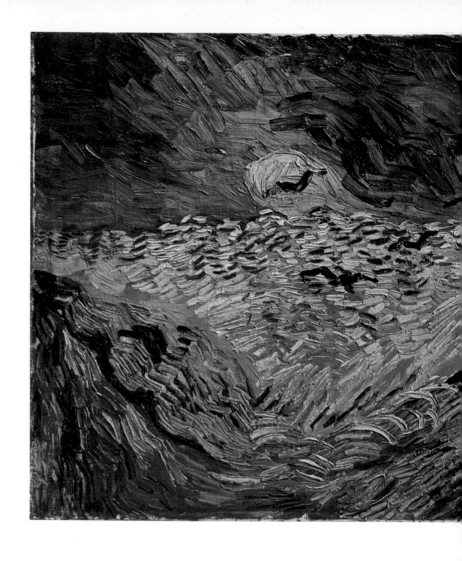

82 Champs de blé aux corbeaux. Juillet 1890. Cornfields and Ravens.

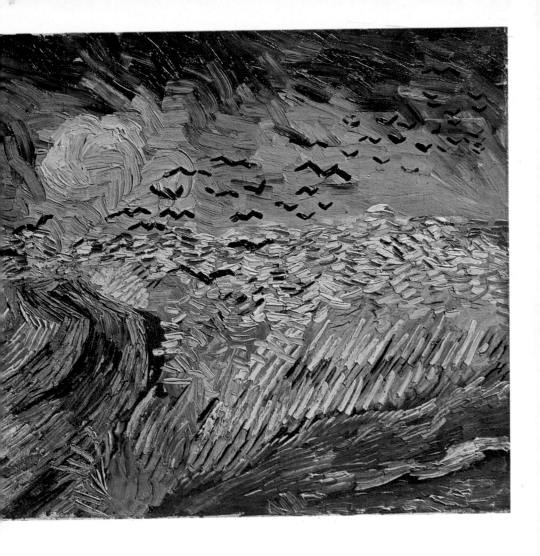

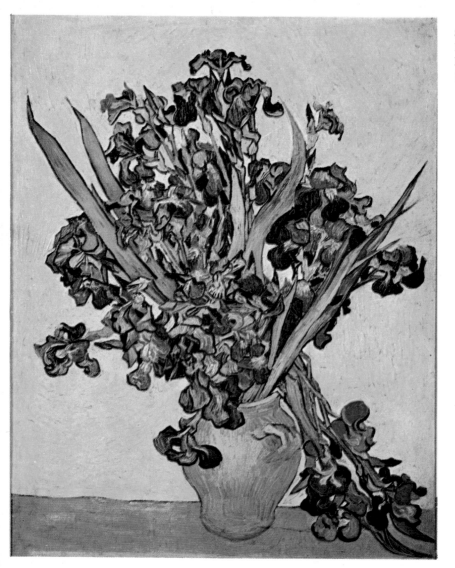

83
Les Iris.
Mai 1890.
Irises.

84→
L'Église
d'Auvers.
Juin 1890.
The Church
at Auvers.

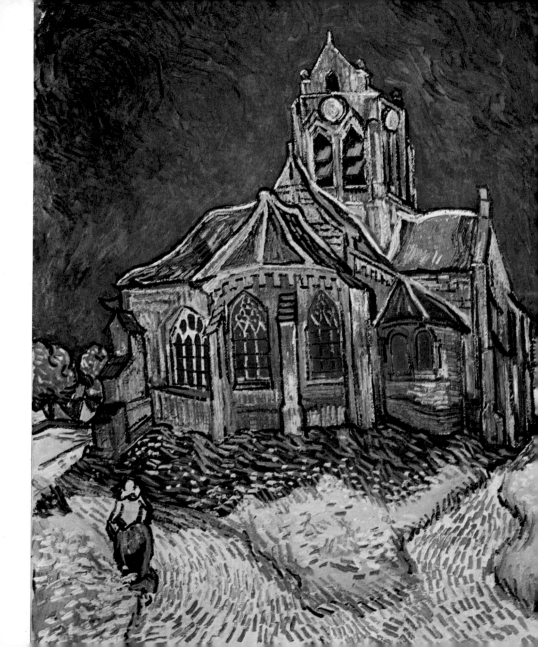

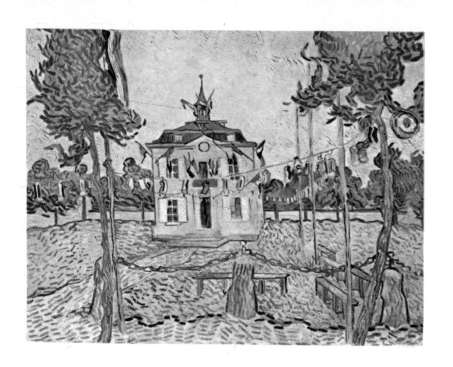

85
La Mairie d'Auvers le 14 juillet.
Mi-juillet 1890.
The Mairie at Auvers on July 14th.

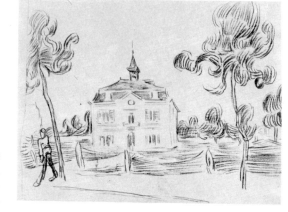

86
La Mairie d'Auvers.
Juillet 1890.
The Mairie at Auvers.

88
Jardin avec paysanne.
Mai-juin 1890.
Garden and Houses.

87
La Barge. The Hay Stack.

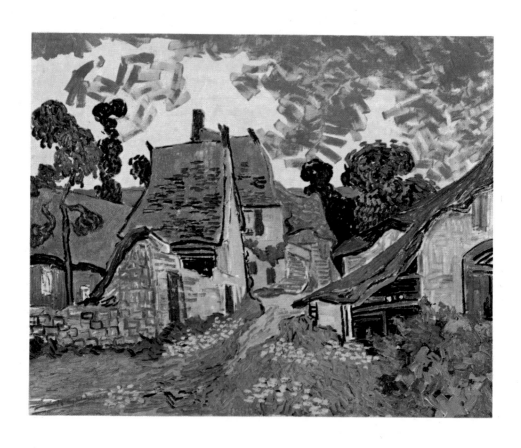

39 Rue à Auvers. Juillet 1890. Street at Auvers.

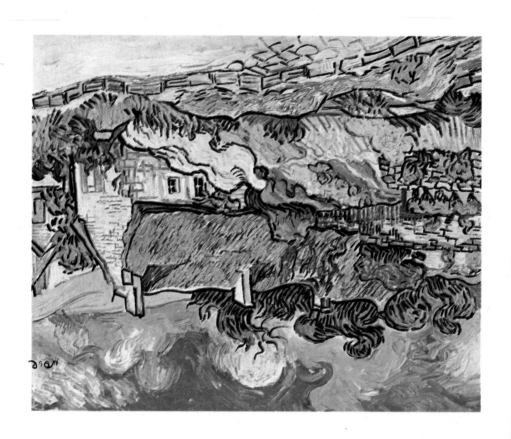